LOUIS COMFORT TIFFANY *at* THE METROPOLITAN MUSEUM

ALICE COONEY FRELINGHUYSEN

The Metropolitan Museum of Art

WITH THE PUBLICATION OF THIS *Bulletin*, THE MUSEUM PAYS
TRIBUTE TO A LATE BENEFACTOR, LILLIAN NASSAU, WHO, DURING
HER LONG CAREER, PLAYED A MAJOR ROLE IN THE REVIVAL OF
INTEREST IN THE WORK OF LOUIS COMFORT TIFFANY.

The exhibition "Louis Comfort Tiffany at The Metropolitan
Museum of Art" is made possible by TIFFANY & CO.

Reprint of *The Metropolitan Museum of Art Bulletin* (Summer 1998)
© 1998 The Metropolitan Museum of Art
Design: Emsworth Design

All photographs, unless otherwise noted, are by Anna-Marie Kellen, Bruce
Schwarz, and Carmel Wilson of The Photograph Studio of The Metropolitan
Museum of Art.

On the covers: *Water-lily table lamp,* 1904–15. See page 74. Title page: Border
design from mosaic garden landscape (detail), ca. 1905–15. See page 48.

Beginning in July we will celebrate the 150th anniversary of the birth of Louis Comfort Tiffany (1848–1933) with an exhibition drawn almost exclusively from the Museum's collection of some three hundred objects—lamps, mosaics, blown-glass vases, enamels, ceramics, jewelry, and stained-glass windows, the last probably the most celebrated of his creations for their brilliant colors and intricacy of design. The largest of these, a favorite of our visitors, is a fully rendered autumnal landscape in glass flooded with a golden light. When the window was dedicated in 1925, Museum President Robert W. de Forest, who donated it, stated, "Mr. Tiffany stands quite by himself among the great artists of our time.... There is hardly any important museum, which admits modern work, that does not contain specimens of his craftsmanship."

Indeed, the Metropolitan had owned a fine group of Tiffany's Favrile glass vases since 1896, only three years after he began to make them. This gift was the generous donation of Henry Osborne Havemeyer, who, with his wife, Louisine, was among the first individuals to seriously collect the hand-blown iridescent and colored glass, and the Havemeyer assemblage of early Tiffany vases remains the largest in any institution. It is not only significant in number but also because it documents precisely glasses of the first three years of production: many vases bear original paper labels, and some even original prices. They provide ample evidence of the artist's preoccupation with color and nature and his innovative techniques, which enabled him to turn out a wide variety of glasses. Almost thirty years after the Havemeyers made their gift, Tiffany augmented it with a loan of more stylistically developed vases from the years 1897 to 1913 and several of his enamel pieces. After his death they were given to the Museum by the Louis Comfort Tiffany Foundation.

We are also grateful to other individuals who have added to our collection with distinction. The two prized grapevine windows were the very generous gift of Ruth and Frank Stanton, who also donated the table lamp illustrated on page 71. Recently, Mr. Stanton donated the evocative dogwood window in memory of his wife, Ruth Stephenson Stanton. We are especially fortunate to have the very rare and complete garden landscape mosaic as a gift of Lillian Nassau, who, when Tiffany's work had fallen out of favor, recognized his great skills as a craftsman and colorist. The entrance loggia from Tiffany's summer home, Laurelton Hall, the centerpiece of the south end of the Engelhard Court in The American Wing, was gratefully received as a gift of Jeannette Genius McKean and Hugh Ferguson McKean, in memory of Charles Hosmer Morse. In addition, it should be noted that this publication reproduces a number of the more than four hundred presentation and working drawings by Tiffany and his studios, most of which were purchased with gifts, including those from Walter Hoving and Tiffany's daughter Julia T. Weld.

The author of this *Bulletin*, Alice Cooney Frelinghuysen, curator of American decorative arts, summarizes Tiffany's career, traces themes in his works, and highlights his technical prowess, illustrating superior examples from our collection. She is also the curator of the exhibition "Louis Comfort Tiffany at the Metropolitan Museum of Art." Our gratitude is extended to Tiffany and Company for its generous assistance toward the realization of this exhibition. We would like to thank specifically William R. Chaney, its chairman.

Philippe de Montebello
Director

INTRODUCTION

Louis Comfort Tiffany (1848–1933) embodied the artistic spirit of the Gilded Age. The over half-century in which he worked in the decorative arts, from the 1870s to the mid-1920s, was a time of experimentation, intense scrutiny of aesthetic ideals, and proliferation of new styles in the world of art. The period also saw renewed interest and new ways of working in many media, watercolor, enamels, and glass among them, which Tiffany embraced with a true seriousness of purpose. Tiffany was intensely passionate about the visual world around him. His artistic vision informed all aspects of his life, in which he demonstrated a multitude of talents as an architect, painter, designer of interiors and landscapes, and of all aspects of the decorative arts. Tiffany worked in more media than any other artist of his era.

Tiffany was both a product of his times and a progenitor of a new artistic vision. Early on he was exposed to the finest craftsmen and designers who conceived and fabricated luxury objects in gold and silver for the firm of his father, Charles Lewis Tiffany, in New York City. Although Louis Tiffany left little by way of personal journals or letters, one can deduce a persona that was flamboyant, theatrical, colorful, and fastidious. He had a flair for the dramatic in his personal life that extended into the art he created. Furthermore, he held himself and all those who worked for him to the highest standards and was obsessive to the point of perfectionism.

Tiffany heralded in America a continuity of design whereby he created a total work of art, in which he was as concerned with each part as he was with the whole. Together with his studio of artists, glassmakers, stonemasons, mosaicists, modelers, metal workers, wood carvers, potters, and textile workers, Tiffany orchestrated pattern and texture, color and light to create a single aesthetic expression.

In many ways, Tiffany was a direct participant and product of the Aesthetic Movement (mid 1870s–mid 1880s), which conferred a new, higher status on the decorative arts. He drew on exotic and historical sources and was attracted to the arts of China, Japan, ancient Greece, Egypt, Venice, India, and the world of Islam. His travels nourished his interests in stained glass, mosaic, architecture, and watercolor. He responded to the tenets of the British reform movements and emulated many of the methods of British designer William Morris (1834–1896). Tiffany appreciated the fine hand craftsmanship championed by the Arts and Crafts Movement, and he encouraged it in his studios. Craft, however, was not his ultimate goal. He introduced an artist's vision into his decorative work.

Tiffany's creativity peaked at virtually the same moment that Art Nouveau burst on the scene in Europe in the mid-1890s, and his particular version of it shared with its other practitioners a dependence on new interpretations of nature. Many glass and pottery vases, enamels, and pieces of jewelry, the design and production of which he oversaw during this period, were clearly organic interpretations of plants, insects, and birds. What began as formal interpretations of nature grew into a love of lush naturalism, and as his artistic career progressed, he became increasingly preoccupied by illusionistic depictions of landscapes and flowers. His was not an intellectual approach to his art; rather it was a sensory one, providing a visual feast of color, light, and texture.

Post–Civil War prosperity produced patrons who were not merely wealthy but also cultured and who shared an aptitude for experimentation. They were poised for Tiffany, who coupled his artistic ambitions with a unique marketing ability that enabled him to publicize his wares to an extent formerly unknown in America. Perhaps learning a lesson from his very successful father, Tiffany utilized the great international fairs of the late nineteenth century as promotional vehicles for his artistic work. He first exhibited his oil paintings at the 1876 Centennial Exhibition in Philadelphia and later at the 1889 Exposition Universelle in Paris. It was the World's Columbian Exposition of 1893 in Chicago, however, that was a watershed event in Tiffany's career. Over a million people visited his exhibit, which was the subject of numerous accounts in the press and the catalyst for many new commissions. During that period the Parisian dealer Siegfried Bing saw Tiffany's work, and his assessment of it led to his sponsorship of Tiffany in Paris and throughout Europe. Tiffany continued to make strong showings and receive awards at the international fairs, notably Paris in 1900, Buffalo in 1901, Turin in 1902, and St. Louis in 1904. As a result, his work was widely known and critiqued with acclaim throughout America and around the world.

Louis Comfort Tiffany (1848–1933) in the late 1880s. Photograph courtesy of J. Alastair Duncan Ltd.

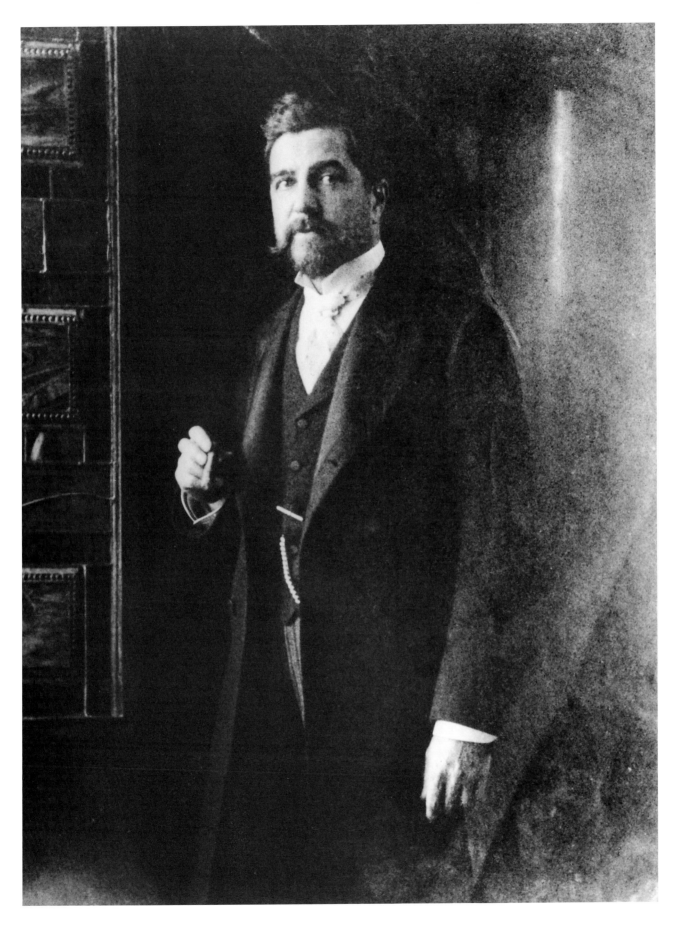

THE EARLY YEARS

Although Louis Tiffany's introduction to the decorative arts was through the silver, jewelry, ceramics, and glass displayed in his father's Union Square showroom, his first creative effort was in painting. At fourteen he was enrolled in the Eagleswood Military Academy in Perth Amboy, New Jersey, where during the next three years the foundation for his artistic career was laid. The tonalist landscape painter George Inness (1825–1894) lived at Eagleswood from 1863 to 1867, and Tiffany's acquaintance with this artist, from whom he is known to have received inspiration and informal instruction in drawing and painting, dates from this period.

By the time he left school, Tiffany was committed to a career in the arts rather than to the family firm. His decision to study painting crystallized in 1866, shortly after he returned from a long trip to England, Ireland, France, Italy, and Sicily, where he made sketches of the places he had visited. In 1867 he exhibited his work at the National Academy of Design. It was during his second trip to Europe in 1868, however, that he encountered the exotic cultures that shaped the direction of his career. In Paris he visited the studio of the painter Léon-Adolphe-Auguste Belly (1827–1877), who specialized in orientalist landscapes and Islamic genre scenes derived from his own travels to North Africa and the Near East. In the spring of 1870, following in Belly's footsteps, Tiffany traveled with fellow artist Samuel Colman (1832–1920) to Egypt and North Africa, visiting Morocco, Tunisia, and Algeria. Recalling the trip years later, he credited it with awakening his painterly eye:

When first I had a chance to travel in the East and to paint where the people and the buildings also are clad in beautiful hues, the preeminence of color in the world was brought forcibly to my attention. I returned to New York wondering why we made so little use of our eyes, why we refrained so obstinately from taking advantage of color in our architecture and our clothing when Nature indicates its mastership.

In the 1870s Tiffany gained recognition as an artist. He was elected an associate member of the National Academy

Louis Comfort Tiffany (1848–1933). *Snake Charmer at Tangier, Africa,* ca. 1872. Oil on canvas, 27 ½ x 38 ½ in. (69.9 x 97.8 cm). Signed and dated(?): (lower left) *Louis C. Tiffany*—[illegible]. Gift of Louis Comfort Tiffany Foundation, 1921 (21.170)

of Design at twenty-two and joined various professional organizations, including the American Watercolor Society and the Society of American Artists. During this period he painted many canvases inspired by his travels; North Africa, particularly Morocco, caught his imagination. No subject could better evoke this exotic culture than *Snake Charmer at Tangier, Africa*, completed in 1872, one of his first oils depicting scenes from his visit (opposite). When *Snake Charmer* was exhibited in New York at Snedecor's Picture Gallery in September of that year, a *New York Times* critic described it as "one of the most notable pictures in every way that Mr. Tiffany has yet produced." Tiffany, apparently concurring with the critic, displayed his canvas, along with four other orientalist scenes, at the 1876 Centennial Exhibition in Philadelphia, and, rather than selling it, kept it for his personal collection. The painting later hung at Laurelton Hall, where it remained until 1921, when it was given to the Metropolitan by the Louis Comfort Tiffany Foundation through the Museum's president Robert W. de Forest, a close friend of the artist and a relative by marriage.

The picture's rich palette of earth tones—deep browns and golds—reveals Tiffany's keen interest in color and light and is reminiscent of the work of Colman, whose paintings, often in pure warm colors and characterized by striking effects of light and shade, were associated with the Hudson River School. Tiffany's canvas, ostensibly presenting a slice of street life in Tangier, evokes a sense of mystery. Although his back is to the viewer, the snake charmer, standing barefoot on an oriental carpet, is clearly the protagonist. He

holds two very animated writhing snakes; the head of one points menacingly at the charmer. Subtle highlights glint in the gold earring and in the snake's eye. Seated musicians accompany the performance, and a group of figures, partially obscured by deep shadows, looks on from the left background.

Tiffany's fascination with Islamic architecture is introduced in this painting. Details such as the carved wood architrave and massive, brightly lit white marble columns with abstractly rendered capitals find expression later in Tiffany's interiors and structures.

Tiffany's later paintings show the influence of the growing American interest in French Impressionism. Mostly intimate plein air scenes, featuring carefully staged vignettes of family life at his country homes, they display a high-key palette, broken brushstrokes, and flat perspective. Through the early 1890s he continued to paint and exhibit his pictures, including two cosmopolitan European market scenes that he exhibited at the 1893 World's Columbian Exposition in Chicago. However, by the mid-1890s Tiffany's serious painting career gave way to his increased activity in the decorative arts. Although Tiffany sketched and painted until the end of his life, his later pictures were seldom shown outside of his own homes or the gallery that he built at Laurelton Hall.

Louis Comfort Tiffany. *Woodland Interior,* 1866 or 1868. Watercolor and gouache on tan paper, 15⅝ x 22 in. (39.7 x 55.9 cm). Purchase, Gifts in Memory of Stephen D. Rubin, 1992 (1992.66.2)

INTERIORS

By the late 1870s Tiffany began to redirect most of his creative energies to decorative work, particularly to the intermingling of all the arts into a complete and unified interior. His philosophy was in keeping with the basic tenets of the Aesthetic Movement, which began in Britain in the 1860s with the work of Charles Locke Eastlake, Christopher Dresser, Bruce J. Talbert, and E. W. (Edward William) Godwin. The movement was at its height in America during the mid-1870s through the mid-1880s and adhered to principles that emphasized art in the production of furniture, metalwork, ceramics, stained glass, textiles, wallpapers, and books, as well as the amalgamation of all of these decorative elements into a unified whole. Surface designs, often utilizing luxurious materials and complex patterns, characterized most interiors of the period. Similarly, Tiffany, a master of surface ornament, believed that aesthetic effect was the primary concern in decoration.

Tiffany's first interior, designed in 1878, was his own home on the top floor of the Bella Apartments at 48 East Twenty-sixth Street in New York, where he lived with his wife and their three children (figs. 2, 3). A complete departure from the prevailing conservative standards of decoration, it must have struck visitors as being very unusual. The four principal public rooms were photographed and published in 1883–84 in *Artistic Houses: Being a Series of Interior Views of a Number of the Most Beautiful and Celebrated*

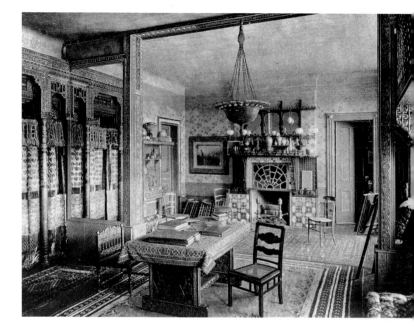

Homes in the United States. These illustrations document the philosophy that served Tiffany well throughout his career. Hardly a surface was left plain: oriental rugs were scattered across floors; Japanese-patterned papers were affixed to walls and ceilings; carved and painted woodwork from India served as architectural embellishment for the windows of the drawing room; colored-and-leaded glass filled window openings; and pictures and objects of various styles and media, including pottery, porcelain, and metalwork from China and Japan—favorite objets d'art of the day—were arranged throughout in artistic groupings. Most of the furniture was remarkably simple, a foil for the proliferation of ornament in the rooms. In the peaked ceiling of the lobby entrance was a large stained-glass panel, raised and lowered by an ingenious pulley system that Tiffany had invented.

Tiffany introduced novel materials into his scheme: richly colored abstract leaded-glass windows, groupings of shields and weapons, and a spiderweb motif of shimmering mica over the drawing-room fireplace (fig. 3). He utilized wallpaper with reflective surfaces, a buff-colored Japanese ceiling paper embedded with bits of mica, and paint in metallic colors. Not slavish in his imitation of exotic styles, Tiffany freely mixed elements of Japanese, Moorish, and Indian decoration. Nonetheless, in a contemporary

1. Opposite: Detail, design for Buffalo Theatre (see fig. 21)

2. Hallway of Louis Tiffany's home at the Bella Apartments, New York City, designed 1878. From *Artistic Houses: Being a Series of Interior Views of a Number of the Most Beautiful and Celebrated Homes in the United States.* New York: 1883–84. vol. 1, pt. 1, facing p. 2. Thomas J. Watson Library

3. Tiffany's drawing room at the Bella Apartments, New York City. From *Artistic Houses.* vol. 1, pt. 1, facing p. 5. Thomas J. Watson Library

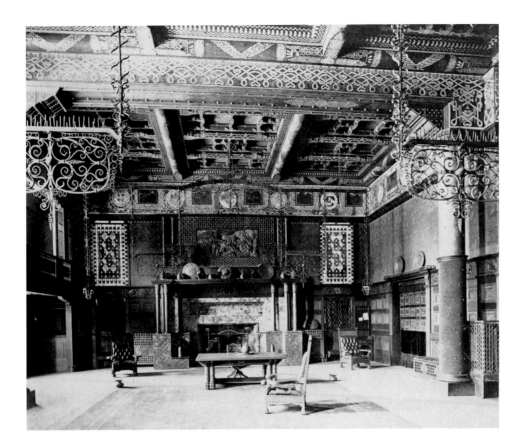

description of the dining room it was acknowledged that while "the Moorish feeling has received a dash of East Indian, and the wall-papers and ceiling-papers are Japanese, there is a unity that binds everything into an *ensemble*, and the spirit of that unity is delicacy."

The appearance of Tiffany's own rooms in *Artistic Houses* proved to be excellent public relations, as it gave him immediate recognition among the wealthy class, from which he would attract future clients. Also illustrated were rooms from seven other homes designed by the firm of Louis C. Tiffany and Associated Artists. The same volume included descriptions and photographs of rooms from houses belonging to such leading society figures as Mrs. Alexander T. Stewart, widow of the department store magnate, and financier J. Pierpont Morgan. Aside from Tiffany, who, with only a few years in the business, was rapidly rising to the top of the field, all of the premier decorators of the day were represented in the publication: John La Farge, Herter Brothers, Cottier and Company, and Roux and Company.

In 1879 Tiffany had joined forces with Samuel Colman; Lockwood de Forest (1850–1932), an artist and collector of Indian artifacts; and Candace Wheeler (1827–1923), a textile designer, to establish the interior-design firm of Louis C. Tiffany and Associated Artists. The four undoubtedly set out to take advantage of growing opportunities provided by the construction boom in houses for the newly rich, who proclaimed their wealth not only through the amassing of collections of art and artifacts but also through the immense mansions built to hold them.

Each partner had different interests: Colman specialized in color and flat patterns for walls and ceilings; de Forest, in carved woodwork and furniture, for which he created a shop in Ahmadabad, India, in 1881; Wheeler, in textiles and embroidery; and Tiffany, who was in charge of the overall design process, in glass. Rooms designed by the firm reflected principles that Tiffany had initiated in his Bella Apartments home: incorporation of exotic decoration inspired by the Near and Far East; delineation of different rooms through variations in theme; a profusion of patterns on ceilings, walls, and floors; and the display of collections, integrating works of art of all kinds into the interior environment. Associated Artists had an impressive client list, including such prominent figures as pharmaceuticals millionaire George Kemp, elder statesman Hamilton Fish, railroad tycoon Cornelius Vanderbilt, president of the Metropolitan Museum John Taylor Johnston, author Samuel Clemens (Mark Twain), and President Chester Alan Arthur. While the firm's alterations for Arthur's White House were obliterated about twenty years after their completion, the other notable public commission, the Veterans' Room of the Seventh Regiment Armory in New York City—albeit missing its original textiles and hangings—remains

architecturally intact (fig. 4). The stenciled and glass decorations that Louis C. Tiffany and Associated Artists added to the Victorian Mark Twain House in Hartford, Connecticut, in 1881, are still preserved. These are the only interiors by the firm known to survive.

Despite its success, the partnership of Tiffany, Colman, de Forest, and Wheeler was dissolved in 1883, and the name "Associated Artists" was retained by Wheeler for her textile workshops. In 1885 Tiffany formed a new company, calling it the Tiffany Glass Company to indicate that glassmaking was to become his primary field. Yet, for the remainder of his career Tiffany continued to work on residential, public, and ecclesiastical interiors to a far greater extent than most scholars and writers have assumed.

About 1883 Louis's father, Charles, commissioned the

prestigious architectural firm of McKim, Mead and White to design a large house on the northwest corner of Seventy-second Street and Madison Avenue in New York City. An unusual instance of communal family living, it provided accommodations on the two lower floors for Charles Tiffany and family, on the third for his daughter, and on the fourth for Louis and family, with his studio on the top floor. Louis was responsible for the interior design, giving full expression to his taste for the Near and Far East. Each highly individualistic room of this large Romanesque Revival structure gave the impression of entering a different Eastern country, notably India and Japan. The house may have been his most exotic creation, incorporating decorative ideas and the kinds of objects that he would return to during the rest of his professional life: the sometimes overscaled architectural elements, such as columns or columnar pilasters; the borrowed architectural fragments, here carved East Indian teakwood wall panels and doors; and the diverse pieces from his collections, which he integrated into the overall design. For example, he arranged his Japanese *tsuba*, highly decorated bronze sword guards, on the walls of his library in place of the more usual stenciled or painted patterns. The leaded-glass windows used throughout provided a variety of effects, ranging from a mosaic-like example, composed of golden butterflies swarming around a Japanese lantern, in the reception room to the five-part bay windows of the library, in which creamy white magnolia blossoms on leaded branches contrasted with clear glass, which allowed the maximum daylight to enter from the outside.

Tiffany's studio was perhaps the most startling room—theatrical, mysterious, almost magical in appearance. A central fireplace dominated the space (fig. 6). Sheathed in concrete, it resembled the trunk of a great tree ending in a "bole" with four rounded openings. Years later he may have been thinking of this structure when he wrote of his great infatuation with trees: "I wanted to bring them into my house—to the very fireside." Tiffany accentuated the cave-like atmosphere by painting the concrete-and-plaster ceiling black, and he suspended a forest of glass lanterns in various colors, shapes, and styles at different heights from wrought-metal chains, conjuring up visions of Islamic mosque lamps. After her visit to the studio, the author Alma Mahler Werfel described it as "a dream: Arabian Nights in New York."

Far more conservative in conception is a proposal for a corner of a room prepared by Tiffany for an unidentified client, probably at the same time he was working on his

5. Entrance to Louis Tiffany's apartment at Seventy-second Street and Madison Avenue, New York City, 1878. From Charles de Kay, "A Western Setting for the Beauty of the Orient," *Arts and Decoration* 1, no. 12 (Oct. 11, 1911), p. 470. Thomas J. Watson Library

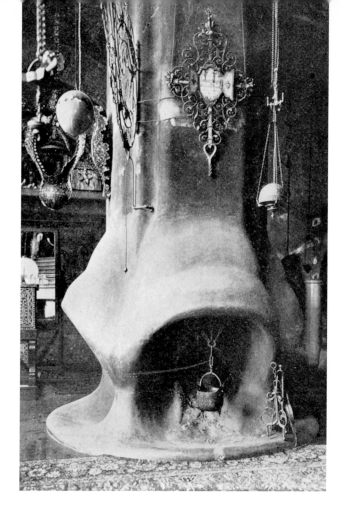

abstract pattern—throughout the 1890s, as can be seen in several surviving church windows from that decade created in conjunction with extensive mosaic work.

Tiffany, drawing on his experience with church interiors, adapted mosaics to a domestic setting in an extraordinary commission for Louisine and Henry Osborne Havemeyer. Given almost free reign and a seemingly unlimited budget, Tiffany, with his former colleague Colman as a partner on the project, began work in 1891 on the decoration of the Havemeyers' New York mansion at 1 East Sixty-sixth Street, which had been designed by Charles Coolidge Haight. Although the Havemeyers, preferring their privacy, were not very active in New York society, they pursued the arts with an intensity rarely matched by their wealthy peers. Rather than follow the precedent of society neighbors, who favored conservative imported or imitation European paneling and furnishings in historical styles in their houses, the Havemeyers set out to support Tiffany's creative originality in their own home.

The house, completed in 1892, was demolished in the early 1930s, but black-and-white photographs taken just

Madison Avenue residence (fig. 7). It incorporates many of the design elements developed during his tenure with Associated Artists: wall patterns, which appear to be painted or stenciled; a metallic stenciled frieze; and a curtain, presumably of silk, with a scrolled medallion placed near the top. As in many of his rooms, this one includes a broad chimney breast faced with glass tile or mosaic. Here the soft green glass mosaic is interrupted by a square of larger, plum-colored glass tiles. True to the design requirements of the day, he provided for the ample display of pottery and porcelain in the étagère-like shelving above the mantel, filled with what appear to be Chinese peach-bloom porcelains. The subtle palette of the leaded-glass window combines opalescent and amber in a simple geometric design resembling mosaic. This treatment is consistent with many of Tiffany's interior windows of the late 1870s, like the example that still graces the Veterans' Room. He employed this window style—relatively monochromatic and in a geometric or

6. Central fireplace in Louis Tiffany's studio at his Seventy-second Street apartment, New York City. From de Kay, "A Western Setting," p. 472. Thomas J. Watson Library

7. Louis Comfort Tiffany. *Aesthetic room interior with window and fireplace*, ca. 1883–87. Watercolor, gouache, brown ink, and pencil, 13 x 10⅛ in. (33 x 25.7 cm). Inscriptions: (lower left) *4 384*; (lower right) *729*. Purchase, Walter Hoving and Julia T. Weld Gifts and Dodge Fund, 1967 (67.654.408)

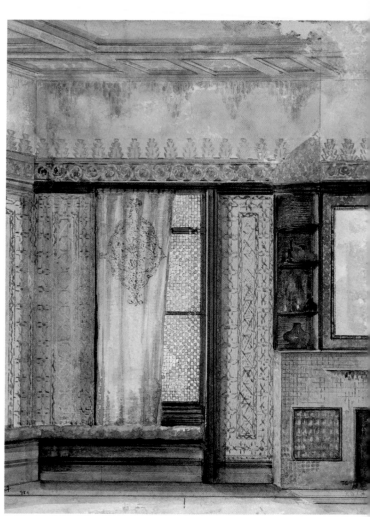

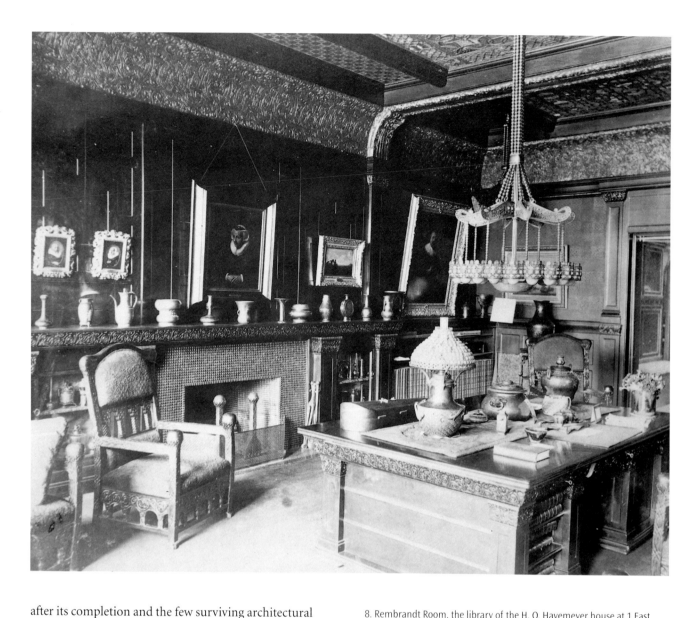

after its completion and the few surviving architectural elements attest to the ingenious eclecticism of the spaces, which were replete with glowing, iridescent glass-mosaic walls, exotic lighting fixtures of Near Eastern derivation, elaborate filigree work in balustrades and fireplace screens, and a dramatic suspended staircase in the picture gallery. The entrance-hall walls were completely sheathed in Tiffany's glass mosaic in soft tones of gold, white, and pale green; the frieze of golden and iridescent blue scrolls was of Islamic derivation. A pair of facing peacocks of shimmering mosaic surmounted the fireplace, and a metal filigree fire screen, encrusted with glass jewels, masked the opening. A similar effect was created in a drawing executed by Tiffany in 1892 for a twisted-and-scrolled metal filigree spandrel intended as an architectural ornament for the home of Mrs. L. Emory of Wilkes Barre, Pennsylvania (fig. 9).

Tiffany carried the mosaic theme of the Havemeyer entrance hall into the library (fig. 8). Called the Rembrandt

8. Rembrandt Room, the library of the H. O. Havemeyer house at 1 East Sixty-sixth Street, completed 1892. Archival photograph, The Metropolitan Museum of Art

Room, it was designed to display the Havemeyers' collection of paintings by that artist and other Old Masters. The silk ceiling was an ingenious resolution of an idea conceived when H. O. Havemeyer and Colman visited the Philadelphia Centennial Exhibition in 1876. The Chinese and Japanese displays sparked Havemeyer's enthusiasm for collecting, which would later grow as he and his wife began to amass a sizable group of modern French paintings. At the fair Havemeyer made a number of purchases, including silks described as "a wonderful lot of brocades of lustrous gold and silver, and rich blues, reds and greens." Colman promised that one day he would fashion them into a ceiling for Havemeyer, and he did so for the house on East Sixty-sixth Street. In her memoirs, published posthumously in

1961, Louisine Havemeyer compared the completed work to the rich mosaics of Constantinople and Sicily:

Like them our ceiling recalled the art of the East both in color and in design. The interwoven pattern of Byzantium prevailed, and when all was completed and fitted into several panels, the design was outlined by a heavy braid and it held the colors which were so beautifully distributed throughout.

The prevailing theme of the library, however, was of Celtic inspiration. The carved oak woodwork and furnishings recalled Viking designs, and the relief ornament featured Celtic interlaced knots. As can be inferred from Mrs. Havemeyer's memoirs, Colman may have superseded Tiffany in the design of the furniture. It must have been large in scale, as evidenced by this armchair from a suite (fig. 10). The carved pattern in low relief with painstakingly applied rubbed finish gave the chairs an "antique" appearance. The covering, of different shades of smooth olive

green plush, was, according to Mrs. Havemeyer, "soft enough to lend itself to being quilted with various colored silks, also in a Celtic design to correspond to the carvings of the woodwork and chairs." The same soft olive green plush was used for the curtains shielding the windows. Eschewing the tradition of red velvet or crimson brocade, the standard wall coverings for displaying Old Master paintings, Tiffany experimented with new treatments, in this case using stenciled olive canvas, chosen to harmonize with other decoration in the room and to create a less distracting background for the paintings.

Japanese art and variations on an oriental theme characterized the Music Room (fig. 11), giving it a delicacy and lightness in contrast to the somber, masculine feeling of the Rembrandt Room. Shimmering Japanese silks provided the background not only for the Havemeyers' Chinese and Japanese works of art but also for the Tiffany and Colman decorations. The room featured a unique chandelier, with airborne blossoms of Queen Anne's lace, fine wire stems, and countless opalescent glass balls, fitted together with

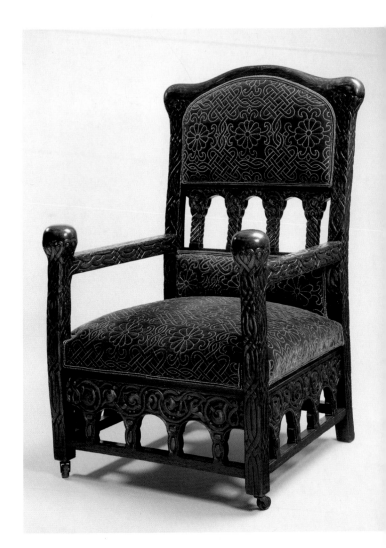

9. Louis Comfort Tiffany. Tiffany Glass and Decorating Company. *Design for a filigree spandrel*, ca. 1892. Ink and watercolor over graphite, 14 x 11 in. (35.6 x 27.9 cm). Inscriptions: (in ink, beside the design, lower right) *324;* (lower right) *scale 3" one foot / Mrs. L. Emory / 46 South River Street / Wilkesbarre [sic], Pa. / Approved NYC 1/27/92;* (stamped, lower right) *Return to Tiffany Glass and Decorating Company;* (paper label) *U111* (in ink) *739.1.* Purchase, Walter Hoving and Julia T. Weld Gifts and Dodge Fund, 1967 (67.654.274)

10. Louis Comfort Tiffany and Samuel Colman (1832–1920). *Armchair from Rembrandt Room, library of H. O. Havemeyer house, New York City,* ca. 1891–92. Oak and silk velvet (replacement upholstery), h. 45 in. (114.3 cm). Purchase, Harry W. Havemeyer and The Frelinghuysen Foundation Gifts, in memory of H. O. Havemeyer, 1992 (1992.125)

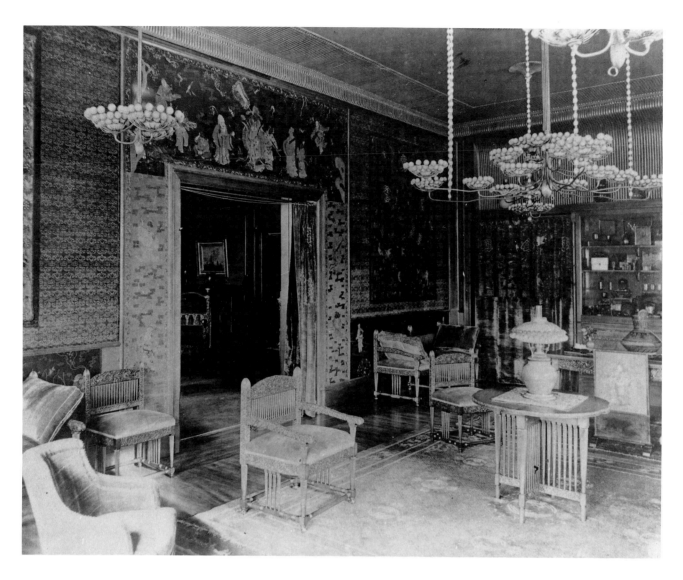

arms that extended over the entire ceiling. The furniture, made especially for the room, derived both in style and in workmanship from Near Eastern examples.

A pair of side chairs similar to the Havemeyer furniture, with carved crest rails of flowers and birds—recalling products of Lockwood de Forest's Ahmadabad workshop—and reeded legs with brass-clawed feet clutching glass balls, is also attributed to Tiffany (fig. 12). Added are bands of micromosaic inlay in lozenges along the arms and in a band along the bottom rail. In a technique requiring extraordinary skill, the minute pieces of varicolored rare woods were combined in a geometric pattern to achieve an Indian look.

The golden color and interlaced design of the carving of the Havemeyer house chairs relate to a highly decorative series of three transom windows from the structure, all of which were originally slightly bowed, indicating that they were installed in one of the first-floor bays. The Museum's example, the only one retaining the curve, was from the left panel of the bay transom (fig. 13). The composition, of leafy

scrolls and blossoms emanating from a pomegranate-like fruit, is subtle in its monochrome palette. Its aesthetic interest derives mainly from the sinuous curves that recall the fluidity and sensuality of the Art Nouveau style, which began in the 1880s and reached its high point in Europe about 1900. Rough-cut amber glass jewels punctuate the composition, giving off a golden sparkle when light shines through them.

The unified effect of the Havemeyer house interiors was achieved by the unusual interconnection of the various branches of the industrial arts, with all of the furnishings and materials under Tiffany's control. The artisans and designers in his workrooms mastered the relevant techniques to produce objects in metal, wood, and glass and to make lighting fixtures and fabrics, as well as hand-blocked wallpapers; they became manufacturers of rugs, glass

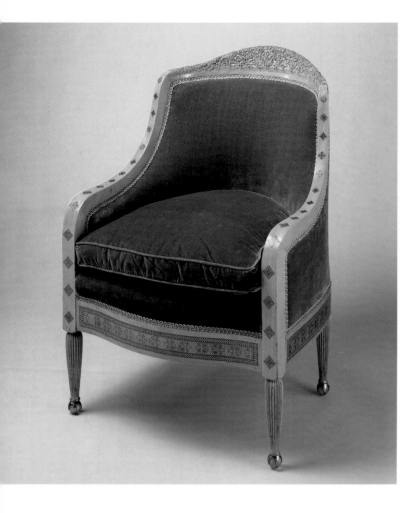

mosaics, and cast ornamental bronzes. Many of the drawings in the Museum's collection illustrate the comprehensiveness and versatility of Tiffany's firms in handling contemporary styles. A scheme for the Short Hills, New Jersey, country house of Mrs. Louis G. Kaufman, probably dating to about 1911–15, features a carved molding in fashionable Chinese taste, with the mantel faced in deep blue-purple tiles molded in a Chinese fretwork pattern (fig. 14). The tiles are interspersed with an arrangement of larger ones, the rainbow hues of which in the drawing suggest the colorful iridescence of Tiffany's Favrile glass, which he developed in the mid-1890s. By contrast, for the Englewood, New Jersey, home of Mr. G. E. Hardy, at approximately the same date, Tiffany departed from his usual Eastern themes and proposed a mantel relating to the designs of British firms working in the Arts and Crafts style (fig. 15). Characteristic are the rectilinearity of the molding, the copper hearth hood, and the spadelike motif above it. The mosaic in natural colors depicts a climbing rose and recalls the work of the Scottish architect and designer Charles Rennie Mackintosh (1868–1928).

Beginning with his earliest design projects during the late 1870s, when he was in partnership with Candace Wheeler, Tiffany—like William Morris—incorporated fabrics into his interiors, as wall coverings and as draperies for both windows and doorways. As was the custom of the day, rooms did not have wood doors. The openings were hung

12. Louis Comfort Tiffany. Tiffany Glass and Decorating Company. *One of a pair of armchairs*, ca. 1891–92. Ash and micromosaic, h. 35⅝ in. (90.5 cm). Gift of Mr. and Mrs. Georges E. Seligmann, 1964 (64.202.1)

13. Louis Comfort Tiffany. Tiffany Glass and Decorating Company. *Window from H. O. Havemeyer house, New York City*, ca. 1891–92. Leaded Favrile glass, 28⅜ x 35⅜ in. (72.1 x 89.9 cm). Purchase, The Frelinghuysen Foundation Gift, in memory of H. O. H. Frelinghuysen, and Friends of the American Wing, 1994 (1994.231)

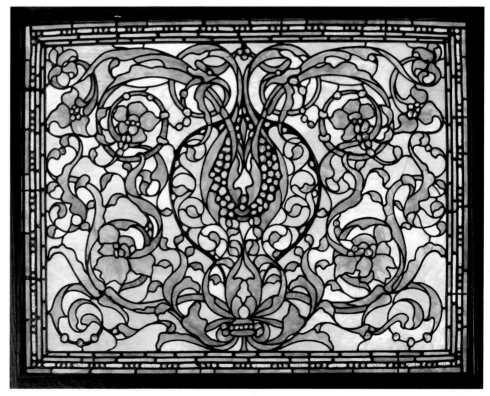

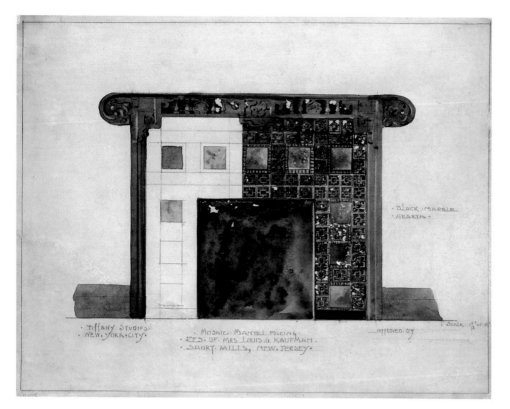

14. Louis Comfort Tiffany. Tiffany Studios (1902–38). *Design for mosaic mantel facing in residence of Mrs. Louis G. Kaufman, Short Hills, New Jersey*, ca. 1911–15. Watercolor and pencil, 13¼ x 17⅛ in. (33.7 x 43.5 cm). Inscriptions: (center) *Mosaic Mantel Facing / Res. of Mrs. Louis G. Kaufman / Short Hills, New Jersey;* (lower left) *Tiffany Studios / New York City;* (lower right) *Approved by [unsigned] / Scale 1 1/2" = 1'0";* (right of image) *Black marble / Hearth.* Purchase, Walter Hoving and Julia T. Weld Gifts and Dodge Fund, 1967 (67.654.15)

15. Louis Comfort Tiffany. Tiffany Studios. *Suggestion for mosaic mantel facing for Mr. G. E. Hardy, Englewood, New Jersey*, ca. 1903–15. Watercolor, 19⅜ x 14¼ in. (49.2 x 36.2 cm). Inscriptions: (in pencil, lower right) *Suggestion for mosaic mantel facing / Mr. G. E. Hardy / Englewood, New Jersey; scale 1" = 1';* (in pencil, lower left) *Tiffany Studios New York;* (in ink, on the mat) *286;* (in ink, bottom right corner) *729.95.19/;* (paper label) *H120.* Purchase, Walter Hoving and Julia T. Weld Gifts and Dodge Fund, 1967 (67.654.16)

with heavy silk, soft velvet, or plush portieres, often embroidered with a central decorative medallion or with an ornamental border at the hem and edge facing the opening. A portiere design by Tiffany's firm is shown on page 18 in deep blue enriched with elaborate gold, red, and green embroidery in a Renaissance-style motif, incorporating a coat of arms (fig. 16). Probably, as can be judged by the drawing, the threads were silk and metallic, which would glimmer as they reflected the light.

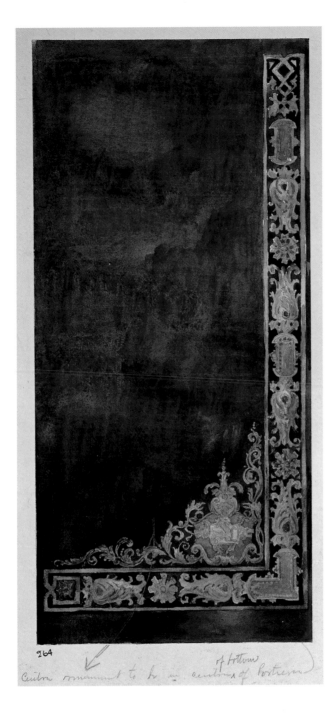

16. Louis Comfort Tiffany. Tiffany Glass and Decorating Company or Tiffany Studios. *Portiere*, ca. 1890–1900. Watercolor, gouache, and pencil on board, 21¼ x 13⅜ in. (54 x 34 cm). Inscriptions: (in ink, lower left of image) *264;* (in pencil) *Ornament center of bottom curtain. . . Call up Smith 2609 Madison;* (arrow drawn from border to text below image) *Curtain ornament to be in center of bottom of portiere / and not in corner as shown— / color of applique* [sic] *to be same as #919. / Blue curtain and material of applique* [sic] */ to be like 2016 / — Note in coloring applique* [sic] *we desire tints to harmonize with leather border;* (in a different hand) *Small borders to apply to back of curtain about same margin as applic———[illegible] 1 inch margin.* The Elisha Whittelsey Collection, The Elisha Whittelsey Fund, 1953 (53.679.1825)

THE THEATERS AND A GALLERY FOR CHICAGO

In addition to work for President Arthur's White House and the dramatic Veterans' Room for the Seventh Regiment Armory, the partnership of Louis C. Tiffany and Associated Artists created elements for a number of other public spaces. In 1880 the firm produced the extraordinary proscenium curtain for Steele MacKaye's Madison Square Theatre on Twenty-fourth Street in New York (fig. 17). Candace Wheeler supervised the embroidery. Destroyed by fire only two weeks after the building opened, it was described in the *New Orleans Picayune* as "a mystic, intense expanse of palpitating needlework: a piece of embroidered satin, representing a jungle of bulrushes and marsh flowers, rooted in a pool of water, over which hover insects of variegated hues and birds of brilliant plumage."

MacKaye's theater was innovative in design and technology. He introduced an ingenious double-tiered stage, which facilitated scene changes between acts, but equally novel was his insistence on artistic interiors utilizing luxurious materials. In an emphatic demonstration of his intent, he did not hire the usual upholsterers to produce the proscenium curtain but retained his former schoolmate from Eagleswood, Louis Tiffany.

From their school days on MacKaye and Tiffany shared a love of the arts and a taste for Eastern culture, and it seems fitting that later, as the theater's most innovative producer and America's most innovative designer, they should join forces for such a project. According to *The Dramatic News* of 1880, MacKaye even wore to the theater's opening "a purple cassock under a white *soutane,* embroidered in floss silk and gold by Mr. Louis C. Tiffany."

Four years later MacKaye began to raise money for a new and better theater, the Lyceum. John La Farge (1835–1910), Tiffany's primary rival, was consulted, and he executed several sketches. However, MacKaye relied once more on Tiffany, who undertook the decorations for a share of stock in the venture. The theater opened in April 1885 and proved to be a financial disaster for its investors. The Lyceum was sold at auction five months after it was inaugurated and was demolished in 1902. A watercolor rendering is all that survives of Tiffany's work (fig. 18). The color scheme is carefully composed in browns, reds, and yellow, with much of the walls and ceiling relieved by silver stenciled-and-painted classically inspired designs. A large hanging light fixture dominated the space. Only sketched in the rendering, it was described when completed in the May 1885 *Art Amateur* as "numerous large pear-shaped globes of opalescent glass swung by silver wires and inclosed [sic] in an almost invisible basket of silver wire. Each holds an electric light and

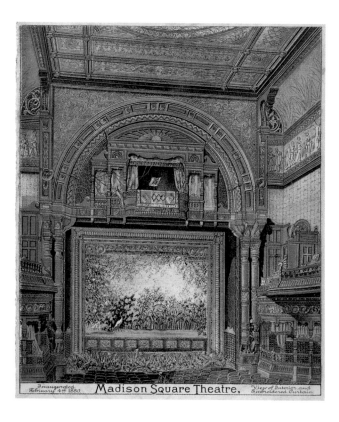

17. *Program for Madison Square Theatre,* 1886. Chromolithograph, 6½ x 5¼ in. (16.5 x 13.3 cm). Printed on cover: (lower left) *Inaugurated February 4, 1880;* (lower right) *View of Interior and Embroidered curtain, The Hatch Lith. Co., New York.* Private Collection

18. Louis Comfort Tiffany. Tiffany Glass and Decorating Company. *Design for Lyceum Theatre, New York,* ca. 1885. Watercolor on board, 10⅞ x 11⅜ in. (27.6 x 28.9 cm). Inscription (lower left): *#799.* The Elisha Whittelsey Collection, The Elisha Whittelsey Fund, 1953 (53.679.1824)

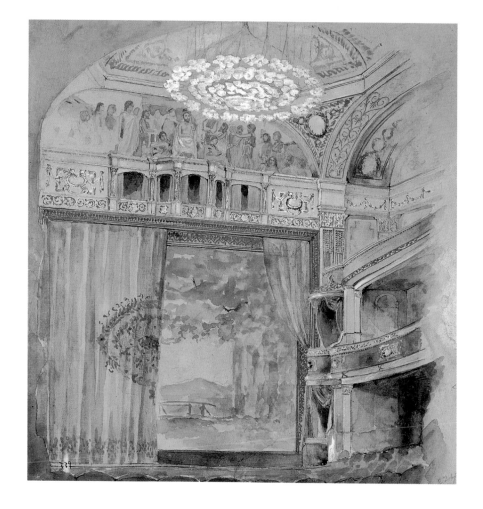

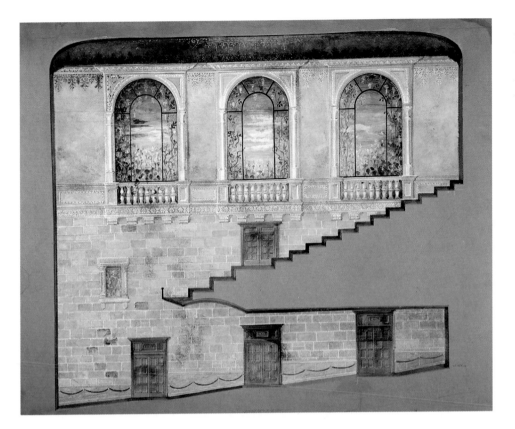

19. Louis Comfort Tiffany. Tiffany Studios. *Design for Hershey Theatre, Hershey, Pennsylvania, interior wall,* ca. 1915. Watercolor, cut out and mounted on board; sheet 25⅞ x 32¼ in. (65.7 x 81.9 cm); image 24 x 27⅝ in. (61 x 70.2 cm). Inscriptions: (lower left) *C. Emlen Urban;* (center) *Suggestion for / Decoration.* Purchase, Walter Hoving and Julia T. Weld Gifts and Dodge Fund, 1967 (67.654.10)

20. Louis Comfort Tiffany. Tiffany Studios. *Design for Hershey Theatre, Hershey, Pennsylvania, light fixtures and ceiling decoration,* ca. 1915. Watercolor, gouache, and silver paint, 20⅞ x 20¾ in. (53 x 52.7 cm). Inscriptions (from original mat): *C. Emlen Urban, Architect;* (signed) *Approved by Louis C. Tiffany.* Purchase, Walter Hoving and Julia T. Weld Gifts and Dodge Fund, 1967 (67.654.13)

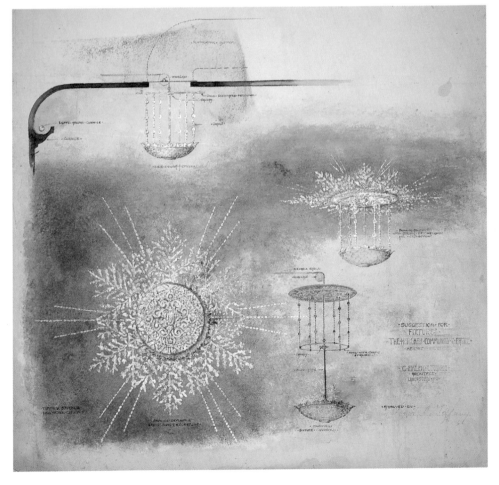

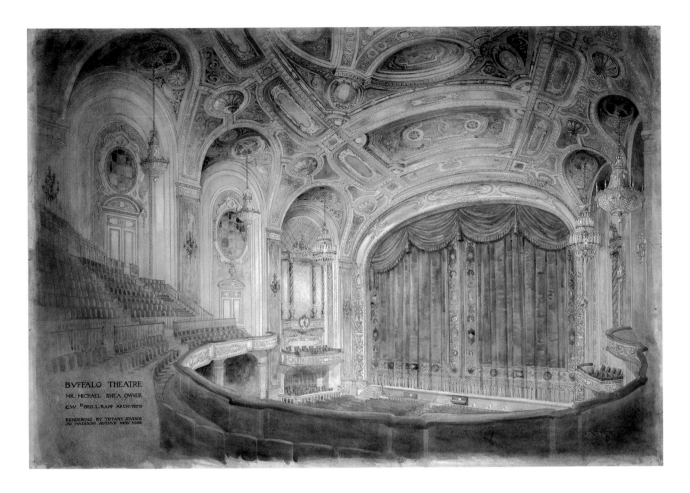

reflects the prismatic tints." The Lyceum was the first theater to utilize electricity for overhead fixtures and the stage.

The dramatic aspects of Tiffany's work made him an especially appropriate choice for theater interiors, and he continued to be active in this field through the four subsequent decades. Drawings survive from the 1910s and 1920s for two theater designs by Tiffany Studios. A rare series of five sketches represents a scheme that was never carried out. In about 1915 Milton Hershey, industrialist and confectioner, proposed a new theater for the community he founded in Pennsylvania in 1909. He hired C. Emlem Urban, a local architect, to design the building, and Tiffany Studios (the name formally adopted by Tiffany's glass company in 1902), the interiors (figs. 19, 20). The drawings indicate that the firm was responsible for the general color scheme, the floral leaded-glass windows on the aisle, and the snowflake-like chandeliers integrated into the Studios' silver decoration on the midnight-blue ceiling, which must have given the appearance of a sky full of twinkling stars. The project was delayed because of the death of Hershey's wife in 1915 and the beginning of World War I. By the time it was reactivated, between 1929 and 1933, Tiffany had retired from working at the Studios. The interiors today in no way reflect the airy and delicate appearance of the original designs.

21. Louis Comfort Tiffany. Tiffany Studios. *Design for Buffalo Theatre, Buffalo, New York*, ca. 1925–26. Watercolor, graphite, gouache, and black ink, 30 ¼ x 43 ¼ in. (76.8 x 109.9 cm). Inscriptions: (lower left) *Buffalo Theatre / Mr. Michael Shea Owner / C. W. & Geo. L. Rapp Architects / Rendering by Tiffany Studios / 391 Madison Avenue / New York;* (signed, lower right) *B. Stanton.* Purchase, Walter Hoving and Julia T. Weld Gifts and Dodge Fund, 1967 (67.654.3)

The sumptuous Buffalo Theatre opened in early 1926 (fig. 21). Although lavish in decorative detail, the interior is more conservative than other Tiffany conceptions, relying on Renaissance motifs. However, it makes full use of the reflective qualities of ornament in gilding, stenciled silver patterns, and shimmering prisms hanging from enormous glass chandeliers. The design as executed is remarkably faithful to the original, which, still mainly intact, is undergoing restoration.

An impassioned collector, Tiffany created many of his interiors to display the holdings of his patrons. He must have been pleased when, in 1893, the widow of Henry Field, brother of Marshall Field, the dry-goods magnate, commissioned him to do a gallery for the Art Institute of Chicago that opened to the public in 1894 (fig. 22). Tiffany's work was well known in Chicago. As early as 1884 he had established in the city a branch of his firm, Louis C. Tiffany and

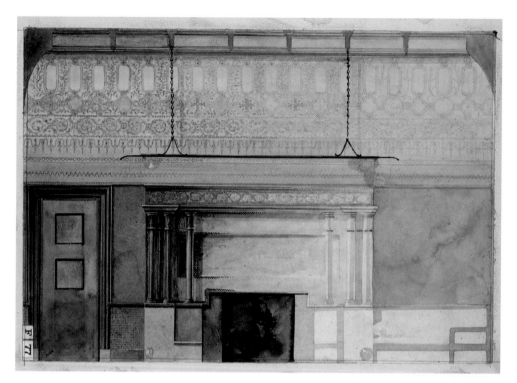

22. Louis Comfort Tiffany. Tiffany Glass and Decorating Company. *Design for Henry Field Memorial Gallery at the Art Institute of Chicago,* ca. 1893–94. Watercolor, 20¼ x 13¾ in. (51.4 x 34.9 cm). Inscriptions: (beside drawing) *Black and gold Mosaic / marble columns;* (paper label, lower left) *F77 / 950.* Purchase, Walter Hoving and Julia T. Weld Gifts and Dodge Fund, 1967 (67.654.4)

Company, Artistic Decorations, and his most dramatic presence there was probably in the glorious mosaic-and-glass chapel he exhibited at the World's Columbian Exposition in 1893 for his recently incorporated Tiffany Glass and Decorating Company (see fig. 23). One of the exposition's most popular attractions, it was probably admired by Mrs. Field and influenced her selection of a designer for the gallery.

To be built in memory of her husband, the gallery was intended as an exhibition space for the couple's collection of nineteenth-century French paintings and a reflection of the room in which they hung in her own home. Although the gallery no longer survives, a drawing of its south wall and a description of it in the *Chicago Tribune,* published shortly after the opening in 1894, reveal Tiffany's skill in accommodating Mrs. Field's wishes and the sophistication of his vision, especially in his inspired use of materials and highly refined palette. Constructed during the period when mosaic decoration was becoming increasingly important to him, the gallery displayed a mosaic floor in soft tones of green, yellow, red, pale pink, and black stone. Surrounded by a mosaic of golden bronze-colored glass, the fireplace was flanked by ebony pilasters with jeweled bronze caps—two to a side—supporting an ebony canopy edged with pale yellow and emerald green glass tesserae. The woodwork was of solid, highly polished ebony, and the door casings and panels inset with tiny squares of mother-of-pearl. Apple green velours hung on the walls behind Barbizon paintings. The dado was a predominately black mosaic, with the incorporation of subtle grays and bronze browns shading to black.

Above the picture wall was a frieze with patterns in metallic silver and bronze on a yellow-green ground, which acted as a foil for the room's most impressive feature, a fourteen-by-thirty-four-foot glass canopy lit from above by electric bulbs. The canopy comprised geometric patterns of small panels in colors that harmonized with the rest of the gallery.

ECCLESIASTICAL INTERIORS AND FURNISHINGS

While Tiffany's commissions for interior designs encompassed those in many different types of buildings—residences, theaters, stores, museums, libraries, schools, clubs, and hotels—the mainstay of this work was in ecclesiastical structures. His career coincided with a period of renewed national economic prosperity, which led to a boom in the building of churches, more than four thousand of which were under construction by 1888. Tiffany Glass and Decorating Company, later Tiffany Studios, was well positioned to be a full-service firm, overseeing a project from preliminary drawings to completion. In 1910 one of the promotional pamphlets published by the Studios stated that its many departments could provide "Ornamental Windows, Frescoes, Mosaics, Altars and Fonts, Sanctuary Lamps, Lecterns, Statues, Altar Crosses, Sacred Vessels, Vestments, Church Needlework." The pamphlet listed more than thirty churches for which the Studios had supplied decorations of some kind—usually for a specific portion of the building, such as the chancel.

23. After Joseph Lauber (1855–1948). *Chapel exhibit by Tiffany Glass and Decorating Company, 1893 World's Columbian Exposition in Chicago*, ca. 1893. Chromolithograph, 10 x 8 in. (25.4 x 20.3 cm). Purchase, Walter Hoving and Julia T. Weld Gifts and Dodge Fund, 1967 (67.654.232)

24. Louis Comfort Tiffany. Tiffany Glass and Decorating Company. *Design for church interior with Noli Me Tangere window*, ca. 1890s. Watercolor, brown ink, and pencil on shaped paper, 18¼ x 20¼ in. (46.4 x 51.4 cm). Inscriptions: (in pencil, lower right) *3847;* (in ink, lower left) *698*. Purchase, Walter Hoving and Julia T. Weld Gifts and Dodge Fund, 1967 (67.654.426)

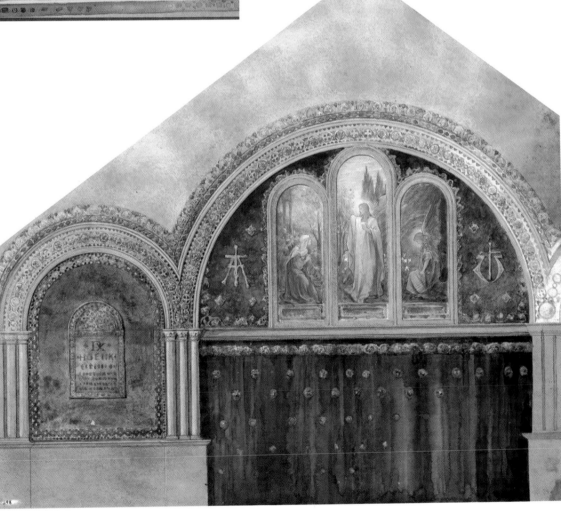

Tiffany's work on church interiors, many with mosaic ornament, gained momentum during the late 1880s. For the 1893 World's Columbian Exposition in Chicago he lavished attention on what he called his "Romanesque" chapel, which, in effect, served as a showroom for the ecclesiastical designs by the Tiffany Glass and Decorating Company (fig. 23). According to a pamphlet describing the exhibit, it featured shimmering mosaics of Byzantine opulence in marble and glass for floors, columns, reredos, altar, lectern, tabernacle, and baptismal font. The candlesticks and an altar cross were richly ornamented with gold filigree and embedded with semiprecious stones. The whole was set in an architectural framework decorated with plaster ornament in patterns of gold and silver encrusted with glass jewels. An enormous hanging light fixture, suspended in the sanctuary, was composed of emerald green turtle-back glass tiles forming a three-dimensional cross. A number of windows featured Tiffany's opalescent glass, further demonstrating the firm's versatility. The chapel display made a significant impact on the public and critics. The primary architectural journal of the day, *The American Architect and Building*

25. Louis Comfort Tiffany. Tiffany Studios. *Design for altar wall from Saint John's Reformed Church, Allentown, Pennsylvania,* 1902–15. Watercolor and graphite on board, 21 ¾ x 29 ⅞ in. (55.2 x 75.9 cm). Inscriptions: (center bottom) *Suggestion for decoration of St. John's Reformed Church / Allentown, PA;* (lower left) *Ecclesiastical Department / Tiffany Studios, New York City;* (lower right) *1/2" scale / Approved by Louis C. Tiffany.* Purchase, Walter Hoving and Julia T. Weld Gifts and Dodge Fund, 1967 (67.654.301)

26. J. A. Holzer (1858–1938). Tiffany Glass and Decorating Company. *Design for chancel of Christ Church, Brooklyn, New York,* ca. 1899. Watercolor and varnish on tissue paper, 27 x 18 ¾ in. (68.6 x 47.6 cm). Image signed: (lower right) *J•A•Holzer.* Purchase, Walter Hoving and Julia T. Weld Gifts and Dodge Fund, 1967 (67.654.8)

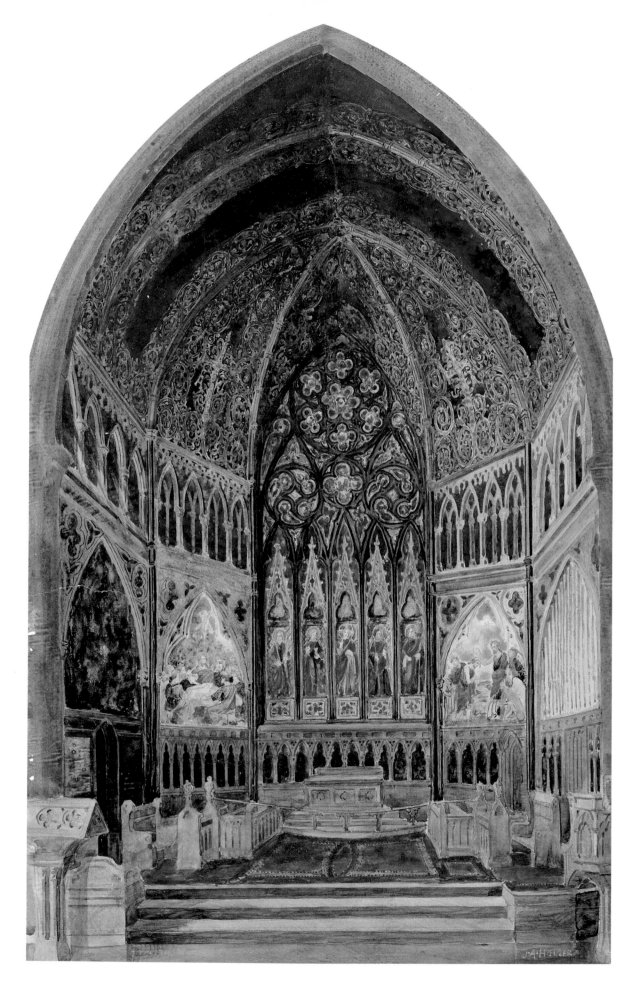

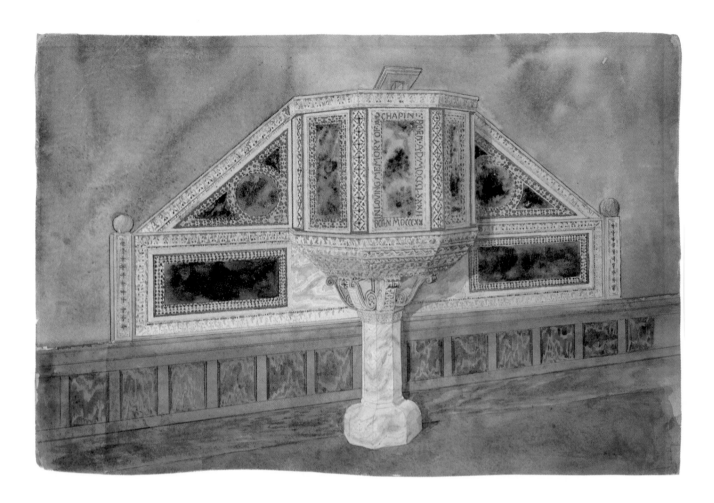

27. Louis Comfort Tiffany. Tiffany Glass and Decorating Company. *Design for a marble pulpit*, ca. 1895–1900. Watercolor and gum arabic, 9⅞ x 14⅞ in. (25.1 x 37.8 cm). Inscription: (on central panel, beginning at lower left and reading clockwise around perimeter) *In loving memory of / Chapin / Born AD MDCCCLXXXII;* (bottom) *Born MCCCXX*. The Elisha Whittelsey Collection, The Elisha Whittelsey Fund, 1953 (53.679.1814)

News, deemed it "the most artistic produced." Crowds of people—said to have numbered 1.4 million—flocked to Tiffany's exhibit.

After the fair closed, Tiffany brought the chapel back to New York, where he displayed it in the company showroom. In 1896 it was purchased by Mrs. Celia Whipple Wallace of Chicago, as a gift to the Cathedral Church of Saint John the Divine, in New York, which was then under construction. It was installed there two years later and used for services until 1911, when the main choir was opened. The chapel was subsequently neglected, and Tiffany offered to remove it for safekeeping. He later rebuilt it on the grounds of Laurelton Hall.

Several of the Museum's drawings illustrate the range of Tiffany's ecclesiastical work. One design, possibly done during the 1890s, shows a partial wall for an unidentified church (fig. 24). Deep plum-colored fabric with woven or embroidered decoration is draped beneath a triptych window depicting Christ's appearance to Mary Magdalen at the tomb. To the left of the central rounded arch is a memorial tablet of a type that Tiffany's workshops produced in some quantity. A proposal for an altar wall for Saint John's Reformed Church in Allentown, Pennsylvania, shows nearly identical architectural detailing, with the same double rounded arches (fig. 25). However, it gives a lighter impression overall, achieved by a brighter palette and by replacing the figural window with mosaic in subtle, light-infused shades of yellow, gold, and ocher.

Gothic was the prevailing architectural mode for churches, and Tiffany often modified his own eclectic tastes to suit those of his ecclesiastical patrons. A rendering of a chancel, identified as for Christ Church, Brooklyn, shows the firm's adept hand at the soaring verticality of Gothic detail, a tall, five-lancet window with elaborate tracery at the top, and a richly ornamented ceiling on a deep blue background (fig. 26). The drawing included designs for the altar, pulpit, lectern, and choir. It is signed by J. A. (Jacob Adolphus) Holzer (1858–1938), who, in his capacity as designer for ecclesiastical projects, created some of the firm's most sumptuous interiors during the 1890s.

Drawings exist of individual components for church furnishings, one of the most highly finished of which is that for a marble pulpit, probably dating to the 1890s (fig. 27). The pulpit, rising from a wood-paneled dado, was to be fabricated in brilliant white and contrasting green-figured marble. The white stone serves as the support and provides the framing elements, which are carved with a repeated, stylized leafy motif reminiscent of Romanesque ornament. The whole is enlivened by panels of green stone framed by mosaic detailing. The artist simulated the texture of polished marble by applying a coating of gum arabic to the green areas, giving a sheen to the normally soft, matte paper surface.

Few of Tiffany's ecclesiastical textiles have survived, and we know them mainly through presentation drawings. The highly detailed example illustrated below depicts a cope intended for the Reverend Edward McCurdy [McCarty?], a priest at Saint Augustine's Church, Brooklyn, from 1876 to 1925 (fig. 28). The embroidery, of a highly complex pattern of interlocking gold strapwork and stylized ivy vines, is reminiscent of thirteenth-century ornament. The hood bears the initials IHS, the monogram for *Jesus*, surrounded by the crown of thorns and leafy vines and blossoms. As depicted, it would have been a sumptuous vestment to be worn for processions and holy days.

28. Louis Comfort Tiffany. Tiffany Glass and Decorating Company or Tiffany Studios. *Design for cope for the Reverend Edward McCurdy [McCarty?], Saint Augustine's Church, Brooklyn,* ca. 1890–1915. Watercolor, brown ink, and pencil, 20 ½ x 13 ⅞ in. (52.1 x 35.2 cm). Inscriptions: (printed in pencil, lower right) *Vestment for Rev. E. McCurdy / St. Augustine's Church / Brooklyn.* Purchase, Walter Hoving and Julia T. Weld Gifts and Dodge Fund, 1967 (67.654.427)

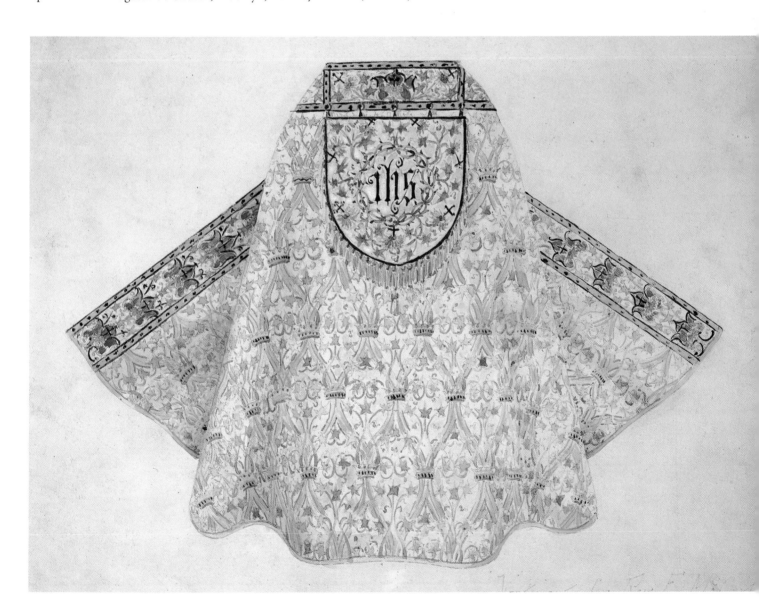

STAINED-GLASS WINDOWS

STAINED-GLASS WINDOWS

Of all of Tiffany's artistic endeavors, stained glass brought him the greatest recognition. During the nearly fifty years that he worked in the medium, from about 1877 through the 1920s, his firm produced thousands of windows for buildings throughout North America—for houses, libraries, department stores, theaters, and especially for churches. Tiffany's windows were also installed in Great Britain, France, and Australia. Consistent with the movement led by William Morris, who established his own stained-glass studio in 1862, and the increased interest in the decorative arts and the artistic interior during the 1870s, stained-glass windows became an important architectural element. They were a requirement for the churches being built in increasing numbers during the last quarter of the nineteenth century. Large and colorful, they were an appropriate and impressive way for wealthy parishioners to memorialize their loved ones. In a new departure for urban dwellings, stained glass became desirable not only for shielding occupants from dreary backyard views but also for the richness they added to the decorative schemes of the interiors.

Beginning in the late 1870s Tiffany and his early rival John La Farge revolutionized the art of stained glass. Before their innovations, the craft had been essentially unchanged since medieval times, when flat panes of white and colored glass were set into slender channeled lead rods, called cames, and held together with lead solder. Details of ornament, modeling, light, and shadow were brushed on the panes with either enamels or dark opaque glass paints and then fired before leading. This art form reached its zenith during the twelfth and thirteenth centuries in France, when soaring tracery windows, like those at Chartres, Saint-Denis, and Sainte-Chapelle, displayed brilliant effects of pure and intense jewel-like colors. The practice of painting on glass increased in the Renaissance and by the eighteenth century led to the decline of the true stained-glass technique.

La Farge and Tiffany, dissatisfied with the anemic colors and poor quality of available window glass, experimented with novel types of materials, achieving a more varied palette with richer hues and greater density. Working independently, they explored the pictorial, coloristic, and textural qualities of stained glass in new and daring ways that completely changed the look of the medium. By 1881 each artist had patented an opalescent glass, which has a milky, opaque, and sometimes rainbow-hued appearance when light shines through it. It was a uniquely American phenomenon that proved to be among the most important advances in decorative windows since the Middle Ages.

The techniques required to manufacture opalescent glass departed radically from contemporary methods. Internally colored with variegated shades of the same or different hues, the glass enabled artists to substitute random tonal gradations, lines, textures, and densities—inherent in the material itself—for the pictorial details usually brushed or etched on the pane. Although Tiffany disliked painting on glass because it dulled the surface and the light shining through, he did not completely eliminate it, using enamels to fill in details, primarily of faces and hands.

Another important innovation utilized by both Tiffany

29. Opposite: Detail, *Autumn Landscape* (see fig. 49)

30. Glass Shop, Tiffany Studios. From *Character and Individuality in Decorations and Furnishings*, New York: Tiffany Studios, 1913, n.p. Thomas J. Watson Library

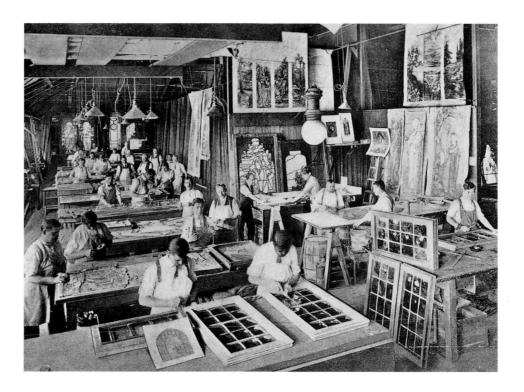

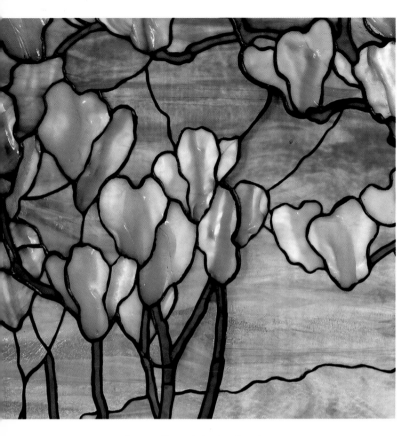

31. Detail, *Magnolias and Irises* (see fig. 37)

and folded the nearly cooled glass to convey the texture of magnolia blossoms.

Tiffany also made significant advances in leading. Traditionally, the cames that held the segments together were supports and not integral parts of the design. In Gothic windows the cames, usually of uniform thickness, arbitrarily bisected compositions in order to reinforce the window structure. Tiffany's windows, by contrast, often had cames of various widths, enhancing or playing down their representational role within the design. In some instances they were specially milled to replicate the natural textures of vines or branches.

Despite technological advances made by Tiffany and his staff, the process of producing a stained-glass window in his studios was one that had remained essentially unchanged for six hundred years. The first step was to prepare one or more watercolor sketches. Usually relatively small, they would show subject, composition, and palette but no leading. Watercolor was particularly suited to this method because the translucency of the water-based paints resembled the translucency of the colored glass. After the client selected a design, it was enlarged into a full-scale cartoon with thick schematic lines to indicate leading. Some cartoons were mere outlines, but others, like that of Saint Anselm, intended for Saint John's Chapel, at the Episcopal Theological School in Cambridge, Massachusetts, are more carefully rendered, with details of facial features, clothing, and background filled

32. Detail, *Grapevine panels* (see fig. 45)

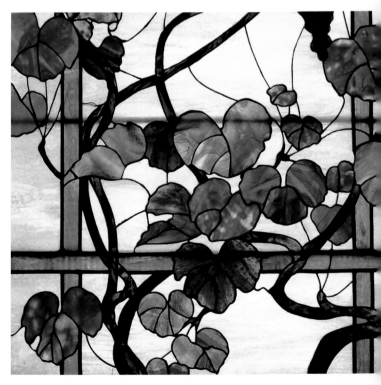

and La Farge was plating—the addition of one or more layers of glass to attain greater depth of color and three-dimensional effect and to blend different hues, which enabled the artist to depict distant forms more convincingly. Drawing upon his new glassmaking techniques and upon his studies of color theory as an artist, Tiffany was able to create windows that had no historical precedent. He "painted" with polychromatic glass that seemed to have limitless pictorial possibilities, blending and shading as an artist does his pigments. His "palette" was his stock of literally thousands of different types and colors of glass, some of which was given dramatic textures and shapes through the use of molds and through manipulation in a molten state.

From the late 1870s through the 1890s, Tiffany and La Farge, using glass in a wide variety of sizes, shapes, and types, often incorporated into the panels specially molded, cut, or rough-chipped pieces, usually small, richly luminous, and resembling precious and semiprecious stones. These sparkling glass gems served as glittering accents to some of the most decorative windows produced in America. Through novel uses of these materials, Tiffany immeasurably expanded the range of glass textures, enhancing his interpretation of subject matter. To replicate water he created rippling surfaces in the red-hot glass with corrugated rollers, simulated drapery swirls by twisting it when molten,

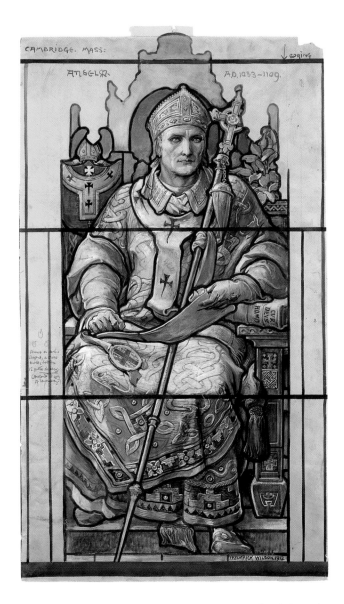

33. Frederick Wilson (1858–1932). Tiffany Studios. *Cartoon for window, Saint Anselm,* 1912. Black ink and wash heightened with white and watercolor mounted on linen, 34¾ x 20¼ in. (88.3 x 51.4 cm). Inscriptions: (upper left) *Cambridge, Mass. / Anselm, AD 1033–109 / spring* [with an arrow pointing down]; (middle right) *arms or seal / argent, across sable / bet. 12 guttes de sang. (Cr… "blazon of episcopacy" / brofonds;* (signed, lower right) *Frederick Wilson 1912.* Purchase, Walter Hoving and Julia T. Weld Gifts and Dodge Fund, 1967 (67.654.299)

in (fig. 33). Such working drawings, large in scale and heavily handled during the fabrication process, are rare survivals.

A duplicate cartoon was made and then cut apart, yielding templates for the cutting of the pieces of glass from sheets selected for color and texture appropriate to the design. So that the lead solder would adhere to the pieces, copper foil was applied to their edges, and then they were assembled into the whole. In some cases, and consistent with traditional stained-glass workshop practice, Tiffany, pressured by the increasing volume of his window production, used the same cartoon for more than one commission.

During the 1880s a number of American artists, among them Robert F. Blum, Frederic E. Church, Samuel Colman, Lydia Field Emmett, and Elihu Vedder, painted cartoons to be transformed into windows by the Tiffany Glass Company. However, by the 1890s Tiffany, to meet the growing demand, needed a large stable of full-time window designers. In addition to Tiffany, they included the Englishman Frederick Wilson (1858–1932), an artist and architect, who worked for Tiffany for more than thirty years and whose specialty was liturgical subjects. Many of the most important figural and landscape designs are ascribed to him. Other designers included Edward Peck Sperry, Joseph Lauber, J. A. Holzer, Will H. Low, and René de Quélin, all of whom were accomplished stained-glass artists in their own right before joining the firm. Although women were often employed by Tiffany in the making of windows, mosaics, lamps, enamels, and jewelry, few achieved designer status. The exceptions were Clara Wolcott Driscoll and Agnes F. Northrop (1857–1953), the better known of the two, who was the principal designer of floral stained-glass compositions.

ECCLESIASTICAL WINDOWS

Memorial windows were the mainstay of Tiffany's religious work. It became standard practice during the late nineteenth century for family members to honor deceased loved ones with the installation and dedication of stained-glass windows. Traditional themes that included pictorial representations of biblical subjects were produced by Tiffany Studios until they closed in 1933, and Tiffany's workshops produced thousands of examples illustrating passages from the Old and New Testaments.

Dated 1905 and drawn by Frederick Wilson, the proposal illustrated on the following page (fig. 34) is for one of six figural windows based on the beatitudes for the balcony of the Arlington Street Church in Boston, which also had Tiffany stained glass illuminating the main floor. It is a highly finished rendering of an angel flanked by two cherubs above a balustrade. The cherubs hold a banderole inscribed "when men shall / Revile you, and Persecute you," part of the beatitude in Matthew 5:11, and the angel's wings join to form the flame emblematic of the Holy Ghost. The colors are loosely applied in delicate washes that evoke those of the final opalescent glass. Other inscriptions, including the scriptural reference, the name of the designer, and the scale of the window, are neatly hand lettered on the drawing. Adorning the arches of all the windows in the series are ornamental borders of scrolled leaves and a cross. The drawing was mounted in a green cloth-covered portfolio with the Tiffany Studios' monogram on the cover. Evidently, the congregation of Arlington Street Church had

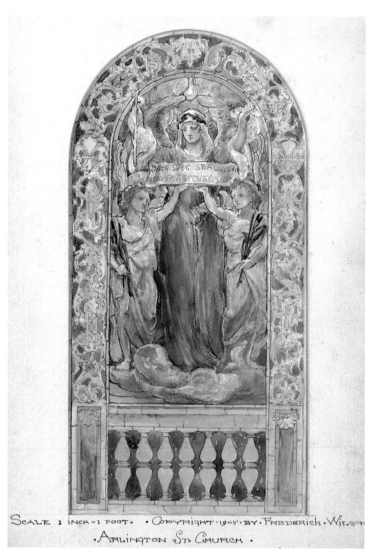

34. Frederick Wilson. Tiffany Studios. *Design for beatitude stained-glass window for Arlington Street Church, Boston,* 1905. Watercolor, gouache, opaque white, brown ink, and graphite, mounted in portfolio; 10½ x 5½ in. (26.7 x 14 cm). Inscriptions: *SCALE 1 INCH=1 FOOT. Copyright 1905 by Frederick Wilson / Arlington Street Church / North Side.* Purchase, Walter Hoving and Julia T. Weld Gifts and Dodge Fund, 1967 (67.654.398)

35. Louis Comfort Tiffany. Tiffany Glass and Decorating Company or Tiffany Studios. *Design for figural window,* ca. 1910–20. Watercolor over graphite, 13⅛ x 4⅜ in. (33.3 x 11.1 cm). Inscriptions: (on the mat, lower left) *SKETCH NO 2802;* (lower right) *scale 1 1/4"=1'0";* (center) *SUGGESTION FOR / WINDOW / MRS. WALTER C. TETOR / KINGSTON, N.Y.* Purchase, Walter Hoving and Julia T. Weld Gifts and Dodge Fund, 1967 (67.654.463)

a long-standing relationship with the Studios: the windows for the church range in the dates of their commemorations from 1898 to 1933.

Unlike the memorial-window compositions of earlier periods, Tiffany's designs often featured figures set in lush landscape vignettes, a departure from the traditional Gothic settings for biblical scenes. A proposal for Mrs. Walter C. Tetor of Kingston, New York, depicts Mary with two children, presumably Jesus and John, one of whom clutches a bouquet of lilies (fig. 35). The three figures stand by a stream with a large pinelike tree framing the composition at the top left and, in the distance, two cypresses against a background of rolling hills and a rosy sun-filled sky.

Deviating completely from accepted themes for church windows, Tiffany eliminated figures from many of his compositions, conferring religious significance on the landscape and the natural world itself. Memorial windows in churches and mausoleums often featured verdant woodland themes, streams meandering through mountain valleys, or floral motifs. A number of options on a floral theme were presented to Cyrus H. McCormick, first president of International Harvester Company, to select a design to honor his late wife at Saint Mary's Episcopal Church in Pacific Grove, California (fig. 36). Two slightly different schemes are illustrated

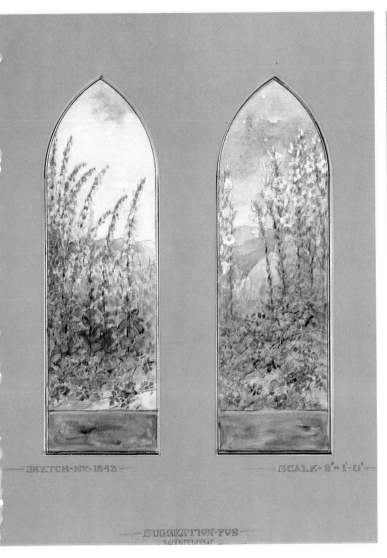

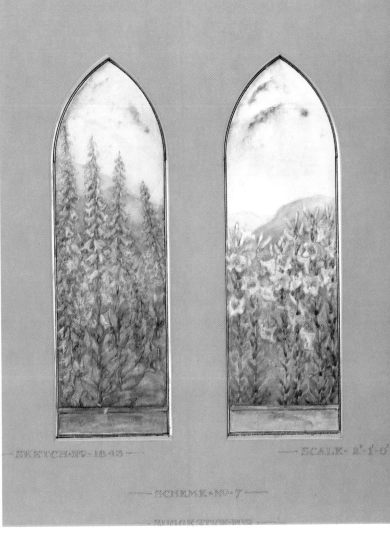

here, both with mountains in the distant background but with alternative varieties of plants. In one are what appear to be foxglove and hollyhock with flowering vines in the lower foreground. In the other, inscribed "Scheme No. 7"— which is closer to the final composition—foxglove and lilies seem to grow out of the base of the window. Neither design was chosen: the window as installed features bold pink foxgloves and white Easter lilies, with the void of the sky in the drawings filled in by a network of purple clematis.

Iris were among the flowers Tiffany preferred for memorial windows. Often used as a symbol of the Virgin Mary, the plant is frequently grown near water, enabling Tiffany to combine the flower with another of his favorite themes that also had religious significance. Numerous variations are known of a scheme with clumps of blossoms, often beside a pool, anchoring the composition in the foreground. In the Frank memorial window, from the family's grand classical limestone-and-marble mausoleum in Salem

36. Louis Comfort Tiffany. Tiffany Studios. *Designs for floral windows for Cyrus Hall McCormick*, 1922. Watercolor, pencil, gouache, ink, and graphite, mounted on sketching boards with window-shaped mounts, 8 ⅝ x 2 ⅝ in. (21.9 x 6.7 cm). Inscriptions: (on mat left, lower left) —*SKETCH NO. 1843*—; (lower right) — *SCALE—2'=1'0"*; (middle) —*SUGGESTION FOR*— / —*WINDOW* — / —*MR. C•H•McCORMICK*—; (bottom left) *ECCLESIASTICAL DEPT.*— / *TIFFANY STUDIOS* / *NEW YORK CITY. NY.* (bottom right) *Approved by* [signed] *Louis C. Tiffany*; (on mat, lower left) —*SKETCH NO. 1843*; (lower right) — *SCALE—2"=1'0*—; (middle) —*SCHEME NO. 7*— / —*SUGGESTION FOR*— / *WINDOW* / —*MR. C•H•McCORMICK*—; (bottom left) *ECCLESIASTICAL DEPT.*— / *TIFFANY STUDIOS* / *NEW YORK CITY. NY;* (bottom right) *Approved by* [signed] *Louis C. Tiffany*. Purchase, Gifts in memory of Stephen D. Rubin, 1992 (1992.67)

Fields Cemetery in Brooklyn, New York, a dense cluster of iris, in shades of purple, from deep, almost black to pale pink and lavender, fills the lower left corner and extends across the bottom of the composition (fig. 37). Providing a latticelike network over the right foreground are the trunk and branches of a magnolia tree, which bears creamy white blossoms tinged with lavender and pink that show Tiffany's

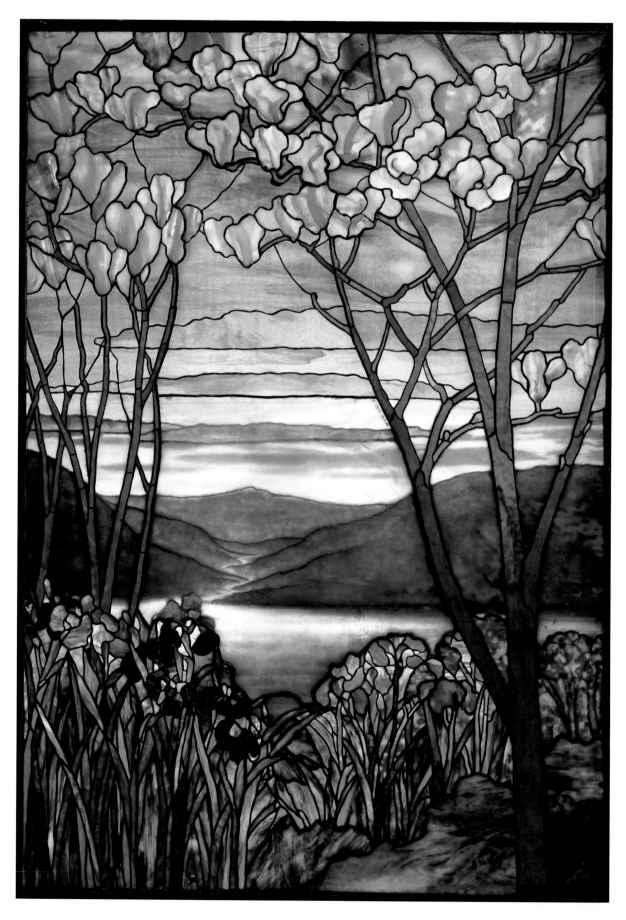

37. Opposite: Louis Comfort Tiffany. Tiffany Studios. *Magnolias and Irises,* ca. 1908. Leaded Favrile glass, 60¼ x 42 in. (153 x 106.7 cm). Anonymous Gift, in memory of Mr. and Mrs. A. B. Frank, 1981 (1981.159)

38. Louis Comfort Tiffany. Tiffany Glass and Decorating Company. *Design for carp window,* ca. 1895–1900. Watercolor and pencil on paper mounted on board; drawing 4⅜ x 6 in. (11.1 x 15.2 cm). Inscription (in red): *#730.* Purchase, Walter Hoving and Julia T. Weld Gifts and Dodge Fund, 1967 (67.654.224)

virtuosity in manipulating and texturing glass. The overlapping mountains and the river zigzagging through a valley and emptying into a broad pool were elements Tiffany often chose for his memorial windows, in which the flowing river symbolized the passage of life of the deceased.

SECULAR WINDOWS

Although an intense interest in naturalism guided most of his secular window designs, Tiffany demonstrated extraordinary versatility in accommodating the needs of his clients, supplying them with virtually any style. His earliest windows tended to be purely decorative, rather than representational, and were sometimes simple geometric arrangements of muted hues. Others were two-dimensional

designs of stylized floral ornament, such as the Havemeyers' transom window of 1891–92, in opalescent and amber or green, enlivened by sparkling glass "jewels" (fig. 13).

By the late 1890s Tiffany had expanded his subject matter to include pure landscapes, vividly depicted flowers and plants, as well as animals, birds, and fish. He designed several windows incorporating fish, often with the swirling water rendered in both the lead lines and the glass. A drawing for a window of a carp swimming in a frothy current probably dates to this period (fig. 38). Its motif and asymmetrical composition recall Japanese art, and the sinuous curves of the rippling water suggest elements of Art Nouveau. One can well imagine this image rendered in Tiffany glass, the water in rich and varied tones of blue and green with the white foam a blue-tinged opalescent.

The cutoff, asymmetrical composition of a window of hibiscus and parrots, done about 1910–20, also reveals Tiffany's debt to the Far East and his brilliant use of color and texture (fig. 40). Shading of the colors within the glass creates form for the birds' heads, and the mixed blues and greens produce their dramatic plumage, with the tail feathers given greater realism through the texture of the glass. Changing hues and manipulation of textures evoke the creamy blossoms and their three-dimensionality. Tiffany's distinctive mottled glass gives the impression of sunlight filtered through the foliage. The window's small size suggests that it was intended for a domestic setting.

Tiffany sometimes revived historical styles in his secular stained glass, such as in the example illustrated here (fig. 41). A proposal for a medallion window for the John B. Murphy Memorial Auditorium of the American College of Surgeons in Chicago, Illinois, it recalls in a general way

39. Louis Comfort Tiffany. Tiffany Studios. *Design for geometric window,* ca. 1902–5. Watercolor, pencil, and black ink, 18 x 13⅛ in. (45.7 x 33.3 cm). Inscription: (on original mat, now removed) *Mrs. J. H. Harbeck, New York City* / [signed] *Louis C. Tiffany / Tiffany Studios.* Purchase, Walter Hoving and Julia T. Weld Gifts and Dodge Fund, 1967 (67.653.2)

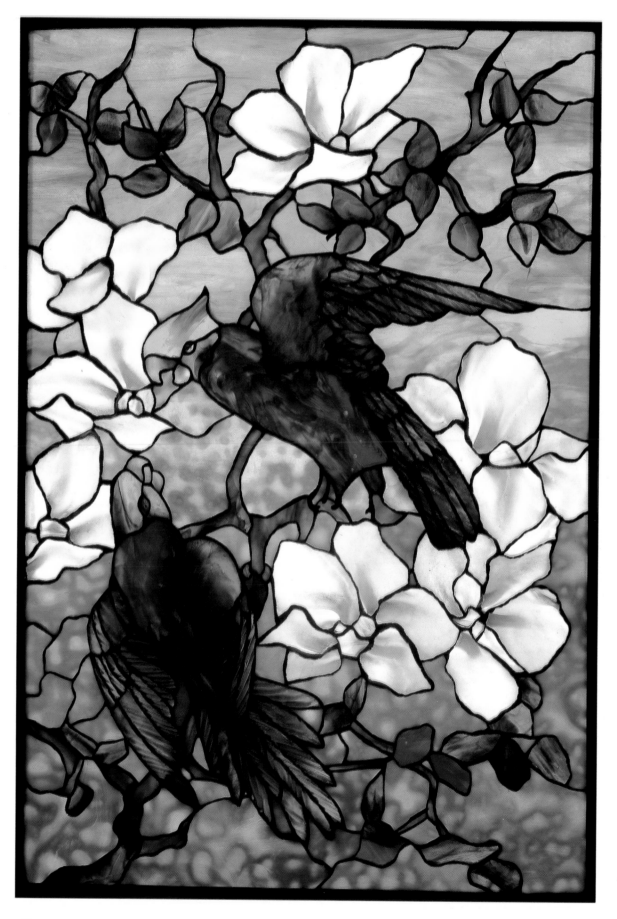

40. Opposite: Louis Comfort Tiffany. Tiffany Studios. *Hibiscus and Parrots,* ca. 1910–20. Leaded Favrile glass, 26 x 17¾ in. (66 x 45.1 cm). Gift of Earl and Lucille Sydnor, 1990 (1990.315)

41. Louis Comfort Tiffany. Tiffany Studios. *Design for medallion window for the American College of Surgeons, Chicago,* ca. 1923–26. Watercolor, graphite, black ink, and gouache on paper mounted on board, 27½ x 12¼ in. (69.9 x 31.1 cm). The Elisha Whittelsey Collection, The Elisha Whittelsey Fund, 1953 (53.679.1816)

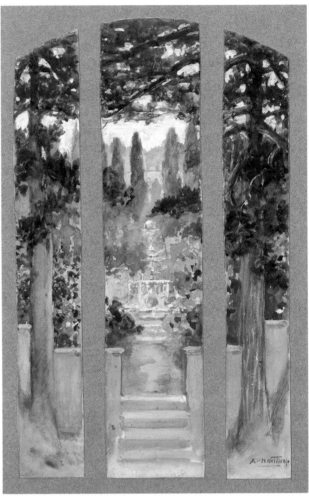

42. Agnes F. Northrop (1857–1953). Tiffany Studios. *Design for window for Sarah Cochran, Linden Hall, Pittsburgh, Pennsylvania,* ca. 1913. Watercolor and gouache mounted on board, 13¼ x 7⅞ in. (33.7 x 20 cm). Inscriptions: (signed, right corner) *AF Northrop / Tiffany Studios / 347 to 355 Madison Avenue / New York.* Purchase, Walter Hoving and Julia T. Weld Gifts and Dodge Fund, 1967 (67.654.229)

similar compositions of interlocking circles in thirteenth-century Gothic churches. In this interpretation, however, the pictorial scenes that would have filled each of the medallions in an ecclesiastical setting are restricted to the central reserve, the others providing a showcase for Tiffany's jewel-like ornamental glass. This design was not accepted, and the commission went to the Willets Studios of Philadelphia, which adapted it to a more traditional Renaissance style.

Tiffany's lifelong preoccupation with gardens inspired him to create some of the most naturalistic depictions of flowers and plants in the history of stained glass. His success with these subjects was enhanced by a heightened awareness of landscape during the second half of the nineteenth century, when publications on gardens and plants—and especially flowers—proliferated. Tiffany amassed a huge library on all

aspects of horticulture, which undoubtedly served not only as a source for his own elaborate plantings at Laurelton Hall but also as an inspiration for his workers. Close attention to garden types is evident in a window drawn by Agnes Northrop for Sarah Cochran, widow of a coal magnate, who built an impressive house, Linden Hall, near Pittsburgh, Pennsylvania (fig. 42). Although said to portray Mrs. Cochran's own grounds, it might as easily have been planned from illustrations of formal Italian gardens. Only the middle panel of a triptych, the proposal features a symmetrical arrangement of cypress trees in the background, a verdant canopy of tall evergreens in the foreground, and a tiered fountain, which serves as a strong central element. The flowers—vigorous hydrangeas, peonies, and hollyhocks in the completed window—are here merely suggested by brushstrokes in watercolor.

An idealized landscape appears in the wistaria window that the Tiffany Studios executed in 1908 for William C. Skinner's New York home at 36 East Thirty-eighth Street, which he shared with his unmarried sister Belle (Ruth Isabel) (fig. 44). According to an entry on September 10 in Skinner's diary, Belle was overseeing Tiffany's redecoration of the foyer and stairway, and he was "also putting in a wistaria window...entire cost $3000." Although often called *View of Oyster Bay* because its pale, dawn-colored water scene has been thought to recall the shoreline around Tiffany's summer home, Laurelton Hall, the window more likely derives its theme from the flowering vines surrounding Skinner's country house, Wistariahurst, in Holyoke, Massachusetts, near the silk mills that built the Skinners' fortune. (The family earlier had called upon Tiffany Studios to provide a window in honor of the senior William Skinner [d. 1902] in Holyoke's Second Congregational Church. In 1919 a fire in the church damaged the building and destroyed the window.) However, inspiration might as easily have come from Tiffany's own plantings at Laurelton Hall, where there was a large trellis for a profusion of the fragrant vines.

Tiffany used the trellis motif in numerous windows, including some of the earliest that he designed for residential interiors. It was a favorite theme in Japanese art, and the interest in oriental designs that dominated the decorative arts during the 1870s and 1880s undoubtedly influenced its inclusion. The trellis, however, also provided the stained-glass maker with an expeditious solution to strengthening the structure itself: the strong linear design could hide unsightly support rods without breaking the image at intervals. The trellis was very effectively incorporated into the Museum's highly ornamental vertical panels of grapevines (fig. 45). The broad leaves are rendered in a wide variety of greens touched with blue, purple, and even pink, and the slender vines—some lead, some glass—twist themselves around the trellis. The artist

further enhanced the illusionistic effects by the addition of molded glass fruit in dark hues of purple and blue. The solid grapes contrast with the fluid linearity of the vines and provide a foil for the colorful, light-saturated leaves.

In the Museum's dogwood window the viewer looks through two grids: one suggesting panes and mullions, and the other a trellis with the tree in full bloom behind it (fig. 47). The tree seems literally to have just burst into flower, with the texture of the white and pale mauve petals given life by the rippling glass. Only a hint of a landscape is incorporated in pale yellow-green in the window's lower half. The soft horizon line is in shaded tones of pale yellow, fading to a deep mauve with a brilliant clear blue sky above. Bicolored, mottled, and opalescent glass conveys modeling and shadow. To achieve further depth of color, certain areas were plated on the back, sometimes in several layers. The asymmetrical composition might indicate that it was originally intended to have a companion piece, perhaps a fall scene. It seems highly likely, as the seasons were an endless source of inspiration for Tiffany.

43. Detail, *View of Oyster Bay*

44. Opposite: Louis Comfort Tiffany. Tiffany Studios. *View of Oyster Bay*, ca. 1908. From the William C. Skinner House, New York City. Leaded Favrile glass, 72¾ x 66½ in. (184.8 x 168.9 cm). Lent by the Charles Hosmer Morse Museum of American Art, Winter Park, Florida, in memory of Charles Hosmer Morse (L.1978.19)

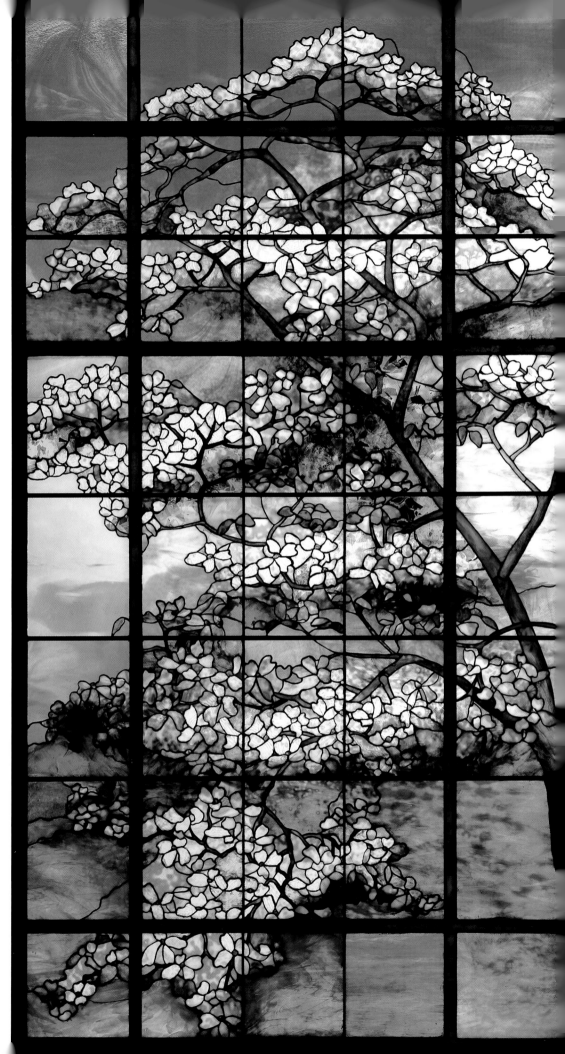

45. Opposite: Louis Comfort Tiffany. Tiffany Studios. *Grapevine panels,* ca. 1902–15. Leaded Favrile glass, each 98 x 36 in. (248.9 x 91.4 cm). Gift of Ruth and Frank Stanton, 1978 (1978.19.2)

46. Detail, *Grapevine panels*

47. Louis Comfort Tiffany. Tiffany Studios. *Dogwood,* ca. 1900–1915. Leaded Favrile glass, 100 x 56 in. (254 x 142.2 cm). Inscription: (lower right, in black enamel block lettering) *TIFFANY STUDIOS / NEW YORK.* Gift of Frank Stanton, in memory of Ruth Stephenson Stanton, 1995 (1995.204)

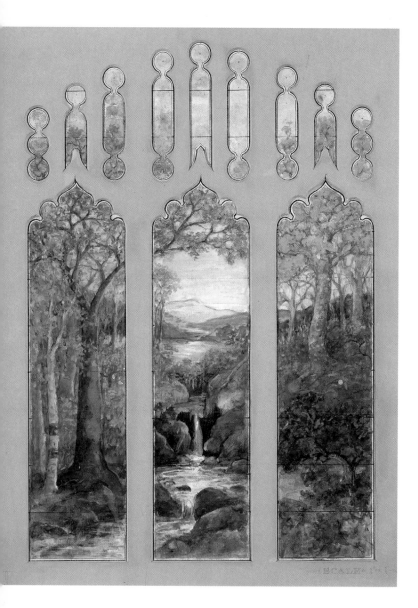

48. Louis Comfort Tiffany. Tiffany Studios. *Design for Towle autumn landscape window,* 1923. Watercolor, ink, and gouache, 18¼ x 13½ in. (46.4 x 34.3 cm). Inscriptions: (center, printed on board beneath watercolor, now almost invisible) *Suggestion for / window / in Residence of / Mr. L. D. Towle / Boston, Mass.;* (lower left) *Approved / D. Towle Feb. 10, 1923 Ecclesiastical Dept. / Tiffany Studios / New York City;* (right, below image) — *scale 1"=1'0";* (lower right) *Approved by / [signed] Louis C. Tiffany; / No. 13-9.* Transferred from Archives, 1958 (58.658)

49. Opposite: Louis Comfort Tiffany. Tiffany Studios. *Autumn Landscape,* 1923–24. Leaded Favrile glass, 11 ft. x 8 ft. 6 in. (335.3 x 259.1 cm). Signature: (lower right) *Louis C. Tiffany.* Gift of Robert W. de Forest, 1925 (25.173)

Autumn Landscape, completed in 1923–24, is a masterpiece of Tiffany's depictions of the natural world in stained glass, drawing upon all of the abilities and techniques he had developed in his workrooms (fig. 49). Although made very late in his career, after he had all but retired from active work in the Studios, it remains one of his crowning achievements in the medium. A quintessential autumnal image, the window is ablaze with glowing colors and rich in surface textures of seemingly infinite variety.

Its subject, a river meandering through a valley with mountains in the distance and a foreground dominated by autumn foliage, was not new for him. As early as 1913 he had published a drawing of a related window, the subject so similar that the birch on the left side of the composition leans at an identical angle and the distinctive figure of the bark is virtually the same on both trees. Emblematic of the River of Life, the subject was a familiar one in memorial windows for churches and mausoleums.

As is indicated on the sketch for *Autumn Landscape,* which, like many of the Studios' designs, bears Tiffany's signature, the window was a private commission for the "Residence of Mr. L. D. Towle, Boston, Mass." (fig. 48). Loren Delbert Towle, a real-estate magnate, was building a massive collegiate-Gothic manor house outside that city, and the style of the building dictated the Gothic tracery design of the frame of the window, which was to be installed on the second-floor landing, just above the porte cochere.

Tiffany manipulated virtually every available type of glass and technique to give his window extraordinary verisimilitude. Mottled glass recreates intense sunlight as filtered through yellow and orange leaves. Confetti glass, embedded with tiny paper-thin flakes of glass in different colors, adds realism to the foliage. Similarly, the boldly colored and marbleized glass simulates successfully the large gray and white boulders in the center lancet. Ripple glass evokes the movement of the water in the foreground, and, by plating several layers on the reverse, the artist created the impression of distant, misty mountain peaks.

The subject may have been prophetic, for Towle did not live to see the window in his home. He died bankrupt in 1924, shortly before the showpiece mansion was completed. The fact that the window was installed in the Metropolitan in 1925 suggests that it was never placed in the house. The estate may not have been able to honor the contract, at which time, perhaps at Tiffany's request, Museum President Robert W. de Forest purchased it with the intention of donating it to the new American Wing.

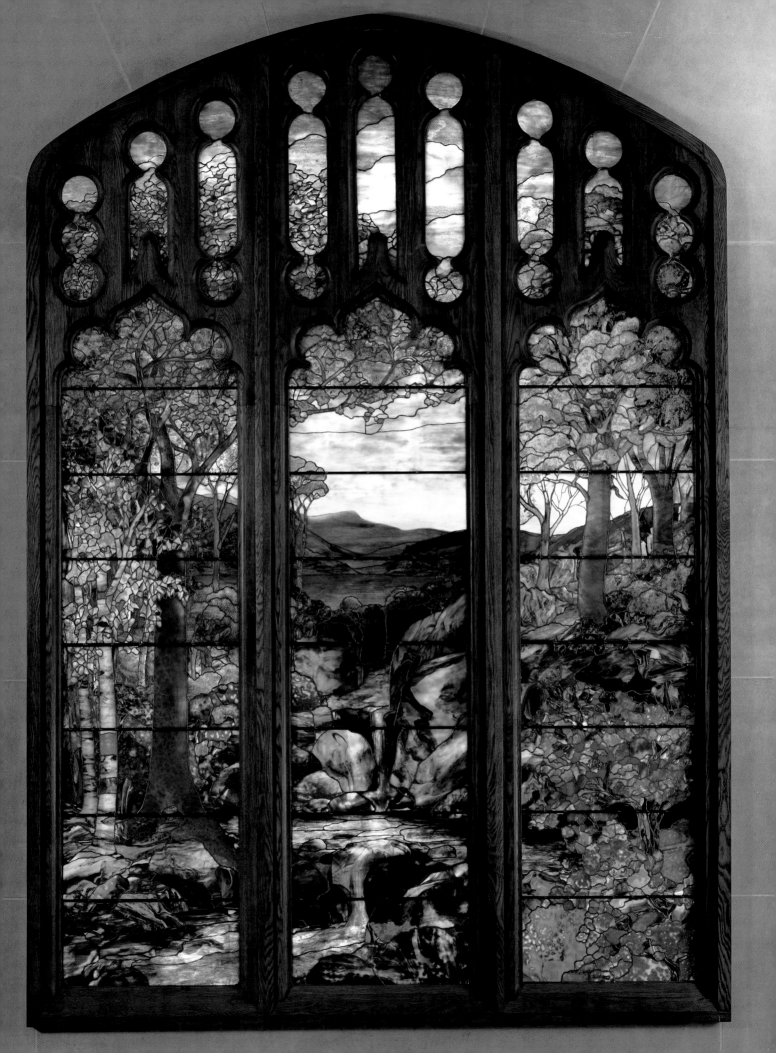

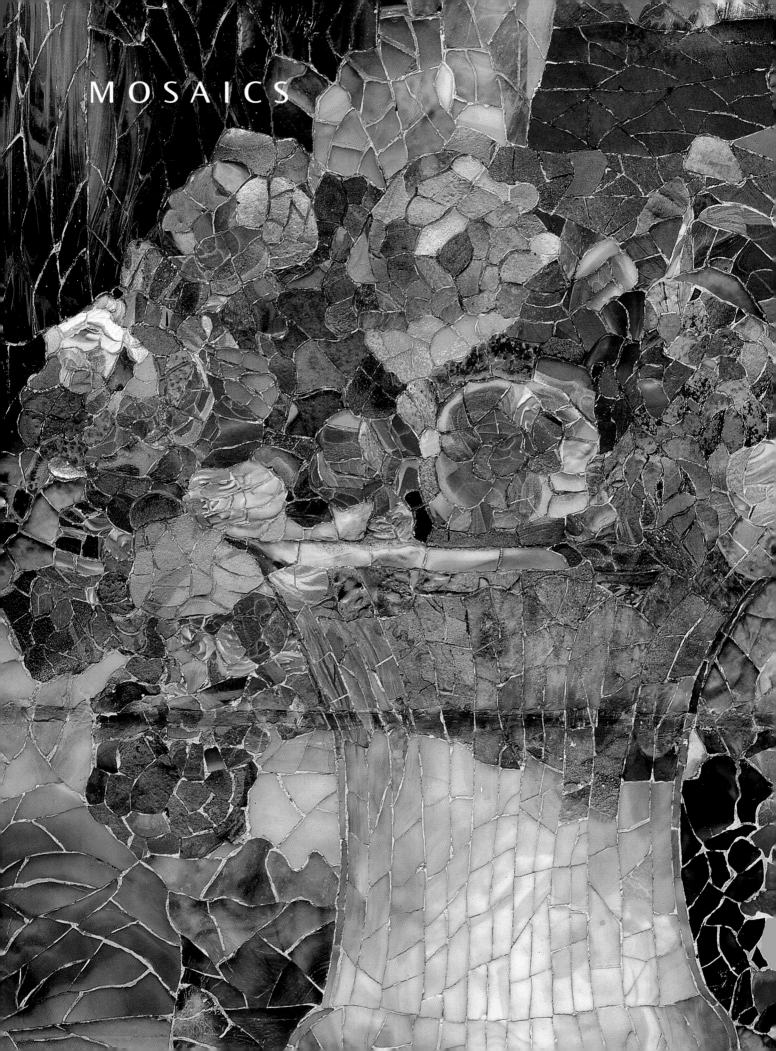

MOSAICS

As an extension of his work in Favrile and stained glass, Tiffany began to design glass mosaics for interiors. In the promotional pamphlet *Mosaics*, issued by the Tiffany Glass and Decorating Company in 1896, he attributed his inspiration to the dazzling interiors of the Byzantine churches he had visited as a young man. (In the same publication potential clients were assured that the medium was practical as well as decorative because it was impervious to moisture, corrosion, fire, and decay.) Tiffany's earliest use of mosaic dates to the late 1870s, when he incorporated glass tiles in colorful patterns into fireplace surrounds. In 1879–80, in a dramatic display, Tiffany selected almost shocking peacock-blue tiles to frame the mammoth fireplace of the Veterans' Room, where they are a gleaming focal point in the otherwise darkly toned north wall.

Just as Tiffany had increased the color range and created illusionistic effects through his developments in colored and textured stained glass, so, too, did he adapt the new materials and methods to mosaics. Rather than using traditional flat, solid-color squares, or tesserae, Tiffany took advantage of his innovative techniques of modeling and shading to produce a wide range of colors within the glass itself. Lustrous iridescence expanded the range further and helped convey a shimmering quality to mosaics of sky or water. Semitransparent glass backed with metallic foil added the depth and brilliance of reflected light.

Tiffany likewise expanded the compositional possibilities of this ancient technique by directing his artists to cut glass into shapes that conformed to specific elements of his design rather than into uniform squares. In this way they were able to achieve more naturalistic effects, such as in the Museum's extraordinary garden landscape (see fig. 54).

As he did for his stained-glass-window compositions, Tiffany prepared drawings of the designs for presentation. In addition, he often produced small maquettes to scale, which showed a portion of the composition with samples of the final materials glued onto it.

The boldness of the design of a lunette depicting a cornucopia overflowing with fruit suggests that it was probably a proposal for the decoration of a public building (fig. 51).

50. Opposite and below: Details, *Garden landscape and fountain* (see fig. 54)

51. Louis Comfort Tiffany. Tiffany Glass and Decorating Company or Tiffany Studios. *Design for lunette of cornucopia*, ca. 1890–1910. Watercolor, graphite, brown ink, and gouache, rice-paper border attached to drawing; 11⅜ x 17½ in. (28.9 x 44.5 cm). Purchase, Walter Hoving and Julia T. Weld Gifts and Dodge Fund, 1967 (67.654.466)

Each brushstroke indicates an individual piece of glass. Various shades of blue, one of Tiffany's favorite colors for mosaics, dominate the scheme. From the central reserve the fruit radiates outward in a lush illusionistic manner in motifs reminiscent of the eye of a peacock feather. The leafy scrollwork border, more stylized and more clearly evocative of Near Eastern prototypes, is rendered in traditional square tesserae.

Two schemes on a more domestic scale for mosaic birdbaths illustrate the variety of coloristic effects achieved by Tiffany's artisans (fig. 52). Drawn for Mrs. Richardson Pratt, wife of the grandson of Charles Pratt, the founder of the Pratt Institute in Brooklyn, New York, they are variations on a floral theme. In scheme A a pedestal adorned with flowers begins with yellow daffodils at the base followed by pink iris and an orange trumpet vine clinging to the upper portion. Scheme B, a simpler design, depicts only purple iris blossoms and green leaves arranged in a deliberately spaced, more abstract and decorative fashion. Delicate gradations of blue, green, and purple "lustre"

glass lining the bowl's interior evoke the water within and the shimmering flow from the central fountain.

During the late 1880s Tiffany began to employ mosaics in earnest. His earliest designs were for churches. For floors he favored colored marble or other stone in shades of cream, green, yellow, and pink. On walls and other architectural elements, he often mixed marble with glass mosaic and even incorporated such materials as mother-of-pearl, seeds, shells, and semiprecious stones. Talented designers like J. A. Holzer and Frederick Wilson, under Tiffany's close supervision, produced compositions for the Willard Memorial Chapel, Auburn, New York (1893–94); Saint Michael's Church, New York City (1895); and Wade Memorial Chapel, Cleveland (1901). The pinnacle of Tiffany's work in this genre was the mosaic he designed for the chapel his firm displayed at the 1893 World's Columbian Exposition in Chicago. Based on a theme previously executed for the entrance hall of the H. O. Havemeyer house, the reredos of resplendent peacocks beneath a jeweled crown was said to have comprised over a million pieces of iridescent tesserae enlivened by sparkling glass gems of gold and blue.

Tiffany expanded his workrooms to accommodate the fabrication of his often elaborate mosaic designs. During the period of some of his most important productions, he entrusted the management of the department to Clara Wolcott Driscoll. Although an 1898 newspaper article

mentions that Driscoll supervised twenty women, a view of the mosaic shop from a 1913 Tiffany Studios pamphlet shows only men working on various stages of production (fig. 53). By this time an entire floor of the Studios was devoted to the manufacture of mosaics.

Church commissions formed the majority of Tiffany's mosaic work throughout his career, and they remained in the domain of the Studios' ecclesiastical department despite the increased demand for designs for domestic and public buildings. Tiffany incorporated elaborate mosaic decoration in both the figural wall panels for Alexander Commencement Hall (1896) at Princeton University and the dome of the Chicago Public Library (1897). His grandest expression in this medium, however, was the majestic proscenium curtain

52. Louis Comfort Tiffany. Tiffany Studios. *Designs for mosaic birdbath,* ca. 1890–1910. Watercolor and pencil, 13⅞ x 11⅞ in. (35.2 x 30.2 cm). Inscriptions: (center, below image) ••*SUGGESTION•FOR—/•GLASS•MOSAIC•BIRD•BATH••/—IN•FLORAL•DESIGN—/ MRS. •RICHARDSON•PRATT—BROOKLYN• N.Y.;* (lower right) *Approved by* [signed] *Louis C. Tiffany;* (lower left)•*ECCLESI-ASTICAL•DEPT••/-TIFFANY••STUDIOS-/-NEW YORK•CITY—N•Y—;* (below left pedestal)-*SCHEME•A-;* (below right pedestal) -*SCHEME•B-;* (between bowls)-*LUSTRE-/GLASS•MOSAIC-/•BOWL;* (below bowls)-*PLAN-OF•BOWL-;* (between pedestals) *SPRAY/-GLASS•MOSAIC•INLAY;* (right of pedestals) *34".* Purchase, Walter Hoving and Julia T. Weld Gifts and Dodge Fund, 1967 (67.654.1)

53. Mosaic Shop, Tiffany Studios. From *Character and Individuality in Decorations and Furnishings,* New York: Tiffany Studios, 1913, n.p. Thomas J. Watson Library

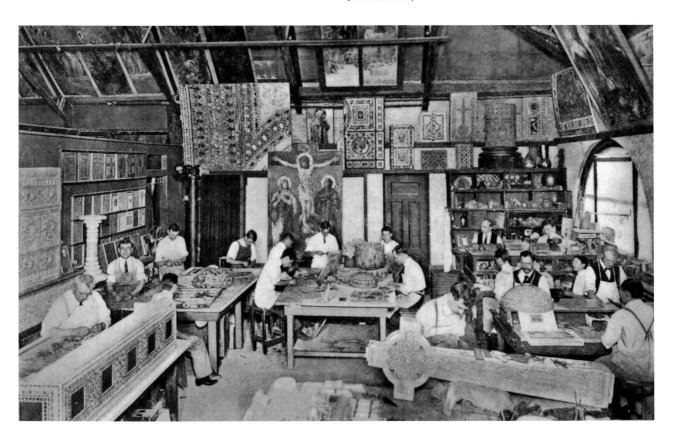

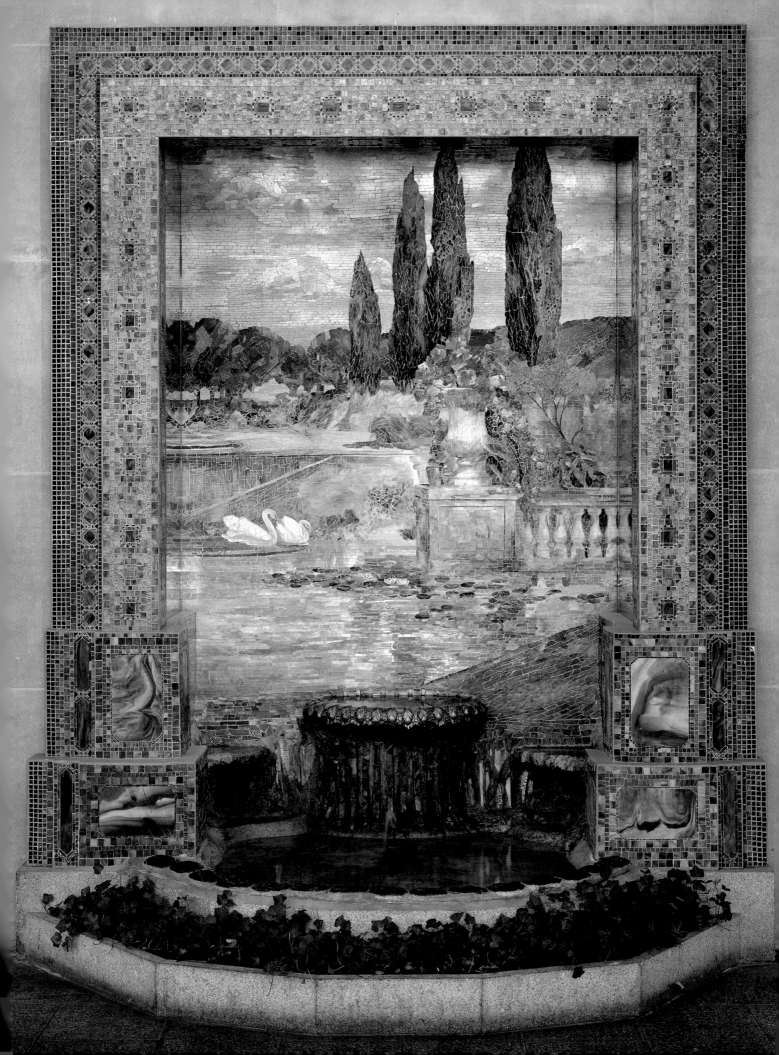

for the National Theater in Mexico City. Completed in 1911, it is a scene of distant snowcapped mountains—a triumph in mosaic. Four years later he completed another large-scale work: the mural that still graces the marble lobby of the Curtis Publishing Company building in Philadelphia. Entitled *The Dream Garden*, it is a landscape panorama after a painting by the American artist and illustrator Maxfield Parrish (1870–1966). The rainbow hues of Tiffany's iridescent glass were especially well suited to Parrish's lush composition and rich palette. Fabricated in sections, the nearly fifty-foot-long mural took a year to complete.

The garden landscape mosaic and fountain display in the Charles Engelhard Court of the Museum's American Wing may originally have been intended for a domestic setting, perhaps as a focal point in the conservatory of a newly built grand house (fig. 54). In this mosaic Tiffany took the medium far beyond its traditional use of creating a flat decorative composition. Nature in all its abundant glory is the subject, offset only by the large marble vase and plinth at

the end of a balustrade similar to those in Tiffany's stained-glass windows (see fig. 34). Roses cascade from the formal vase, next to which is a modest terracotta flowerpot with a single red rose.

This work is a tour de force of mosaic. The tall, slender cypresses, fashioned from Tiffany's distinctive mottled greens and yellows, are set against a pale multicolored sky of iridescent glass (fig. 55). Two swans carve a slender ripple in the placid shimmering pool, which supports a cluster of water lilies (fig. 56).

By freeing the glass from traditional shapes and colors, Tiffany was able to create extraordinary, luminous illusions in mosaic heretofore unrealizable. In this landscape long horizontal slivers accentuate the sky and pool, while vertical tesserae form the cypress trees. Textured pieces convey the veining of leaves in the shrub to the right of the urn. Both intense and subtle, Tiffany's palette, reminiscent of the Ravenna mosaics he so admired, was achieved by juxtaposing tiny shapes of slightly varying hues. Unlike his earlier,

Byzantine-inspired mosaics, which were rich in color but devoid of shading and modeling, his new glass permitted subtle nuances, producing a more faithful rendering of nature. The landscape is framed by a geometric ornamental border dominated by greens and blues with the pattern picked out in shimmering gold-foil-backed textured glass, terminating in an outer border of midnight blue.

The landscape and its fountain were never installed in a patron's home. Rather, they were a feature of Tiffany Studios' New York City showrooms on Madison Avenue. They appear in a promotional pamphlet for the firm's decorative work in 1922, although they probably date to several decades earlier (fig. 57). The landscape and fountain remained on exhibition until they were sold at auction with the other contents of the Studios prior to demolition of the building in 1938.

Also on view in one of the showrooms were two mosaic columns. In a photograph published about 1926 they are seen flanking an entrance in front of shimmering drapery that served as a room divider. The curtain replicated in fabric the details of the columns, including the gold-and-silver scrollwork of the glass-jewel-encrusted capitals and the diapered fringe and long gold tassels suspended from a twisted cord (fig. 59).

Inlaying columns with glass and colored-stone tesserae was a concept from Roman and Byzantine times. Despite the large size of the Museum's example, Tiffany was able to blend his mosaic colors with extreme subtlety (fig. 58). The ground color changes almost imperceptibly from a brilliant iridescent peacock blue at the very top to deeper blues shading to a midnight blue, almost black, at the base. Six similarly decorated columns were said to have been installed in the studio building at Laurelton Hall.

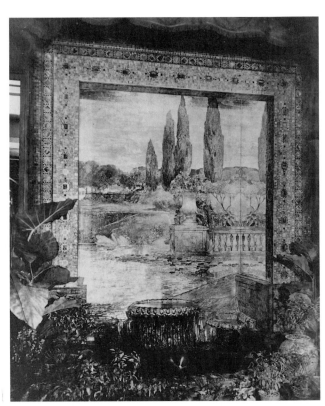

56. Detail, *Garden landscape and fountain*

57. *Garden landscape and fountain* in Tiffany Studios', showroom. From *Tiffany Studios, Ecclesiastical Department,* New York, 1922, n.p. The Elisha Whittlesey Collection, The Elisha Whittlesey Fund, 1962 (62.508.6)

58. Opposite left: Louis Comfort Tiffany. Tiffany Studios. *Mosaic column,* ca. 1905. Favrile glass, cement, plaster capital, h. 11 ft. 1½ in. (337.8 cm). Purchase, The Edgar J. Kaufmann Foundation Gift, 1968 (68.184)

59. Opposite right: Detail, *Mosaic column*

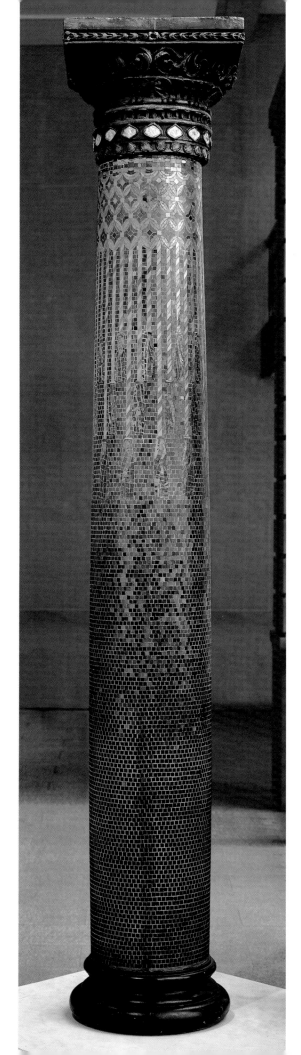

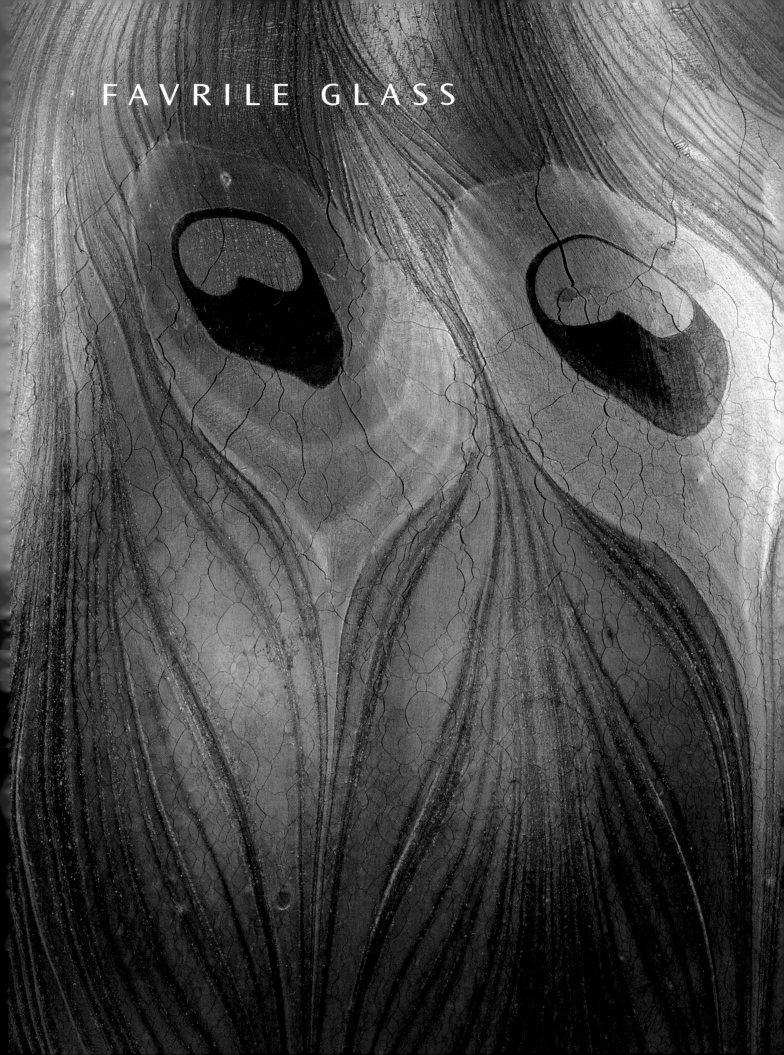

FAVRILE GLASS

By the early 1890s Tiffany had proved himself a skilled glass-maker, developing a method whereby different colors were blended together in the molten state, achieving the subtle effects of shading and texture that he used mainly in stained-glass windows. The application of this technique to three-dimensional form did not take place until 1893, when Tiffany founded his own glasshouse at Corona, Queens, New York. Prior to that year he worked in Brooklyn, at Thill's Glasshouse and at the Heidt Glass Furnace, and, independently, at two glass furnaces that were destroyed by fire. Under the direction of Arthur J. Nash, who mastered the medium as manager for the firm of Thomas Webb in Stourbridge, England, before coming to America, the new company began to produce ornamental vessels. Although often overshadowed by the immensely popular leaded-glass windows and lamps, these Favrile vases, as Tiffany christened them, soon earned him international respect after they were first exhibited in his New York City showroom in 1894, and they remain some of his most creative achievements.

A year or two earlier Tiffany had experimented in blown glass, producing, among other lighting devices, the opalescent globes for the chandeliers in the Havemeyer house. In turning to vessels, Tiffany was responding to changing tastes in the medium that took place here and abroad during the last quarter of the nineteenth century. Beginning with the 1876 Centennial Exhibition in Philadelphia, a major showcase for industrial arts from many countries, the production of art glass soared to new heights. Such objects benefited from the increased preoccupation during the 1870s and 1880s with collecting works of all kinds from around the world, and many of them entered the nation's newly established art museums.

Glass vessels from ancient Rome, the Islamic world, Venice, and Bohemia stimulated the public's appetite for novel forms, colors, textures, and decorations, and glass-makers, including Tiffany, copied them to meet the growing demand. The collections he formed and those of some of his close associates—particularly Edward C. Moore, chief

designer at his father's Tiffany and Company; his partner Samuel Colman; and his client H. O. Havemeyer—had lasting effects on Tiffany's work as well. In addition the highly skilled craftsmanship of the art glass being manufactured at Stourbridge and the rich coloristic effects in the objects made by Émile Gallé in Nancy, France, would further inspire him. Tiffany combined his talents as a colorist, naturalist, and designer with the technology that he had developed for his windows to produce blown glass with surfaces, hues, and forms that were totally new. Talented gaffers in his employ worked the gather of glass as different colors were introduced, combining and manipulating the various hues until the final shape was reached, at which time the whole was often fumed with metallic oxides to achieve iridescence. He gave his glass the name "Fabrile," derived from the Old English *fabrile*, meaning "handwrought," to signify the hand-blown quality, the connotation being that each piece was unique. The name, included on a label on a small vase in the Museum (fig. 62), was changed by 1894 to the more sonorous "Favrile."

When the vases made their first public appearance in Tiffany's showroom, they captivated one contemporary reviewer with their special color effects: "The semi-opaque pieces are charmingly flushed with different tones of uranium yellow, ruby red, and other tints, . . . heightened in some cases by a metallic lustre." Perhaps the first published illustration of Favrile glass appeared in the firm's

60. Opposite: Detail, *Vase* (see fig. 73)

61. *Advertisement,* Tiffany Glass and Decorating Company. *Art Interchange* 36 (February 1896), p. vi. The vases at far left and far right are shown in figure 63.

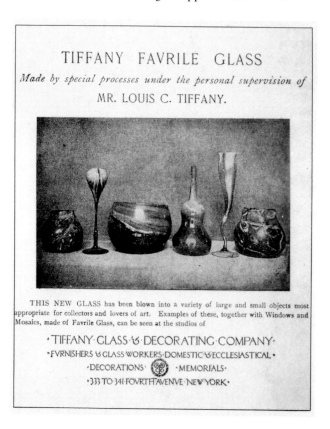

62. Detail, *Vase* (see fig. 65), paper label. Inscriptions: *[TI]FFANY FABRILE GLASS;* (printed in black on label) *9*

63. Louis Comfort Tiffany. Tiffany Glass and Decorating Company. *Vases,* 1893–96. Favrile glass. Left: h. 4⅛ in. (10.5 cm). Gift of H. O. Havemeyer, 1896 (96.17.31). Right: h. 5¼ in. (13.3 cm). Bequest of James H. Stubblebine, 1987 (1987.403.1)

advertisement in the February 1896 *Art Interchange* (fig. 61). Displaying none of the luster described above, these vases, small and relatively thick, may have been experimental (fig. 63). Threads of colored glass were trailed in an irregular fashion over their surfaces while they were being formed. The shapes are not as self-consciously elegant as many of Tiffany's later vessels, and one can see on the vase at right where the gaffer somewhat sloppily sheared off the lip of the blown vase during the finishing process.

Tiffany in his earliest promotional pamphlet (1896) for his Favrile pieces stated that he considered them not merely decorative but appropriate for "collectors' cabinets." In addition to publicizing his wares in advertisements, he promoted them in brochures and through exhibitions, actively encouraging American and foreign museums to acquire them. A notice issued by the company boasted that "examples of this new glass have been secured by the art museums of Paris, Berlin, and Tokio [*sic*], as marking a new epoch in glass." The influential Parisian art dealer and Tiffany's European agent Siegfried Bing, who was instrumental in the dissemination of the Art Nouveau style, was a pivotal figure in arranging for acquisitions of Favrile vases by many foreign museums, including the Musée des Arts Décoratifs, Paris; the Kunstgewerbemuseum, Berlin; and the Imperial Museum, Tokyo. In 1894 Bing chose Tiffany to translate into leaded-glass windows designs by such French

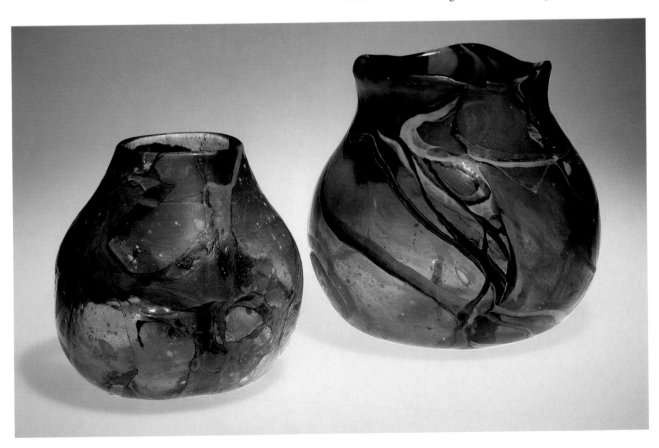

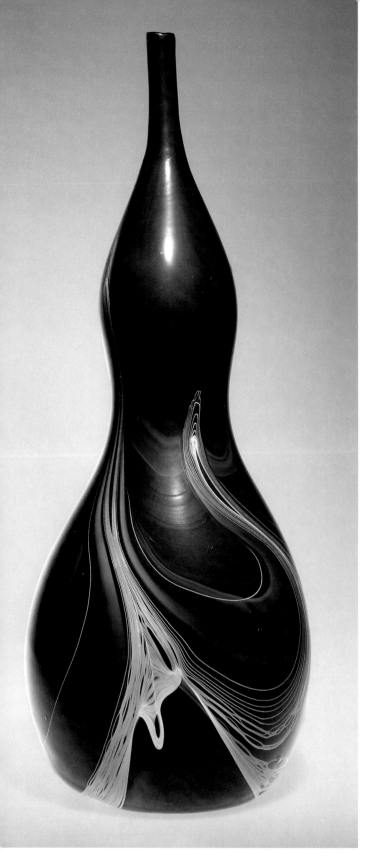

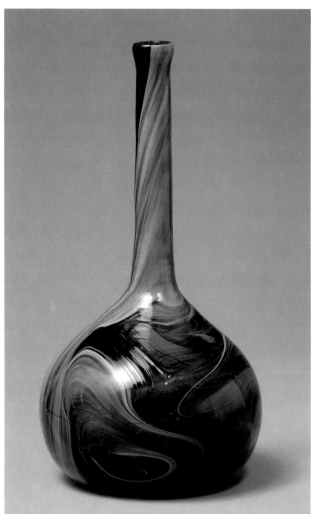

64. Louis Comfort Tiffany. Tiffany Glass and Decorating Company. *Vase,* ca. 1893–97. Favrile glass, h. 20 ¼ in. (51.4 cm). Bequest of James H. Stubblebine, 1987 (1987.403.2)

65. Louis Comfort Tiffany. Tiffany Glass and Decorating Company. *Vase,* 1893–94. Favrile glass, h. 5 ⅝ in. (14.3 cm). Gift of H. O. Havemeyer, 1896 (96.17.43)

avant-garde painters as Pierre Bonnard, Édouard Vuillard, Henri de Toulouse-Lautrec, and Félix Vallotton. When, in 1895, Bing launched a "new art" with the opening of his Paris gallery, L'Art Nouveau, he displayed some of Tiffany's Favrile vases alongside those by Émile Gallé, Karl Koepping, Henri Cros, and George Morren.

As Bing had done abroad, Tiffany began in 1896 a program of placing his favorite examples in American museums. His first success was in June of that year, when the Smithsonian acquired thirty-nine specimens. Later in 1896, undoubtedly at Tiffany's suggestion, the Metropolitan received fifty-six vases and roundels as a donation from H. O. Havemeyer, one of the first collectors of Favrile. (By this time Tiffany had cultivated a special relationship with the Havemeyers, having successfully created the inventive glass-filled interiors for their New York residence.) In offering their objects to the Museum, Mr. Havemeyer wrote: "Since the Tiffany Glass Co. have [*sic*] been making favrile glass, Mr. Louis Tiffany has set aside the finest pieces of their production, which I have acquired for what I consider to be

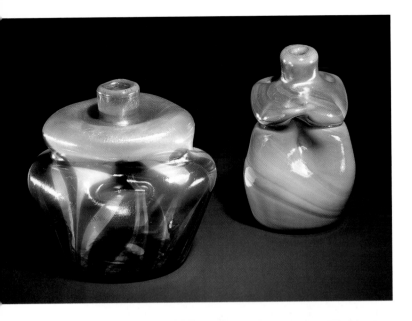

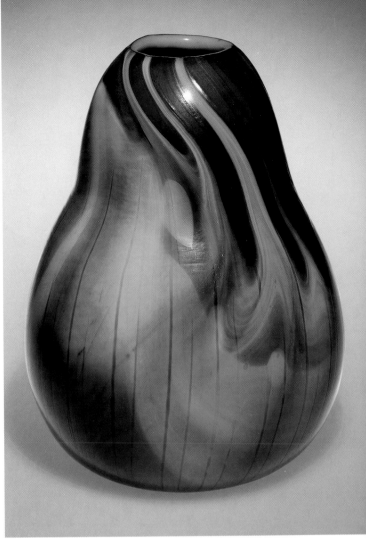

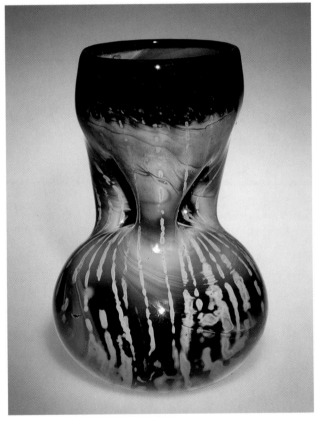

66. Above left: Louis Comfort Tiffany. Tiffany Glass and Decorating Company. *Vases*, 1893–96. Favrile glass. Left: h. 2⅞ in. (7.3 cm). Right: h. 3 in. (7.6 cm). Inscribed: (on underside) *x1991*. Gift of H. O. Havemeyer, 1896 (96.17.46, .48)

67. Left: Louis Comfort Tiffany. Tiffany Glass and Decorating Company. *Vase*, 1893–96. Favrile glass, h. 8⅛ in. (20.6 cm). Gift of H. O. Havemeyer, 1896 (96.17.18)

68. Above right: Louis Comfort Tiffany. Tiffany Glass and Decorating Company. *Vase*, 1893–96. Favrile glass, h. 6¾ in. (17.1 cm). Gift of H. O. Havemeyer, 1896 (96.17.24)

their artistic value. Their number is such now that I am disposed to offer the collection, which is one of rare beauty, to the Metropolitan Museum of Art." Havemeyer specified that the glass was to be arranged in the cabinets by Tiffany personally, with the help of Samuel Colman. By 1900 forty-three museums here and abroad had acquired examples of Favrile glass.

Twenty-five years later Tiffany loaned the Metropolitan twenty-seven pieces from his own collection. Presumably

unhappy with the limited techniques represented by the Havemeyer gift of objects ranging in date from 1893 to 1896, he augmented it with the most highly developed examples of his style from 1897 to 1913. After his death the loan became a gift to the Museum by the Louis Comfort Tiffany Foundation.

The Metropolitan's earliest Favrile wares fall into two categories: purely experimental ones and finely crafted pieces for exhibition and sale through such prestigious venues as international expositions, Bing's Paris gallery, and Tiffany and Company. Vases made probably in the first years of production were of Tiffany's color-melded window glass,

a process resulting in an almost unlimited number of colors mixed together in a single vessel (fig. 65). Some of the early vases are dark, nearly black, with applied threads of glass in contrasting or metallic luster colors that undulate as a result of the vase having been manipulated when molten. On one large example with an attenuated neck, the sensuality of the swollen and waisted form is accentuated by the white and mustard threads following the curved contours (fig. 64). The patterns changed constantly as the glass was expanded and worked on the gaffer's blowpipe. Often, the irregularity of the vase's shape echoes the irregular swirling of the glass threads. Two small bottles display free-form, asymmetrical shapes that look similar to the hand-thrown red earthenwares created by the American art potter George E. Ohr at about the same time (fig. 66).

In the early years of Favrile glass the coloration often favored greens, mustards, and browns, recalling earth and vegetable tones and made even more explicit by the shapes of the vases (figs. 67, 68). As Bing wrote in 1898: "In the artist's hands there grew vegetable, fruit, and flower forms, all [of] which, while not copied from Nature in a servile manner, gave one the impression of real growth and life."

In 1880 Tiffany applied for a patent relating to

the introduction of a new character of glass in colored glass.... The effect is a highly-iridescent one of pleasing metallic luster, changeable from one to the other, depending upon the direction of the visual ray and the brilliancy or dullness of light falling upon or passing through the glass....The metallic luster is produced by forming a film of a metal or its oxide, or a compound of a metal, on or in the glass either by exposing it to vapors or gases or by direct application.

Although he originally intended the technique for colored-glass windows, Tiffany soon adapted it to blown-glass vessels.

Tiffany was widely celebrated for the iridescence of his Favrile products. Much of the contemporary press of the 1890s, prompted by his own public-relations team, claimed that the effects were entirely new. Contrived iridescence, however, was patented even before Tiffany's 1880 application. Notices of such wares, marketed by a Bohemian manufacturer, appeared in the American trade press in 1878. Iridescent glass was also manufactured in Venice, and commercial iridescent glass was exhibited in Vienna in 1873. But of the few glassmakers employing the process, Tiffany was exceptionally inventive in his application of it as an artistic device. The best of this work seems to have a life of its own, changing color with variations in light quality and

intensity—golds transform from pink to deep purple and blues from a bright peacock to a midnight hue (fig. 69). There are striking silver luster effects on the two early vases illustrated on page 58 (figs. 70, 71). The bottle-shaped example displays silver luster in abstract leaf forms on an aquamarine iridescent ground. The curving stems accentuate the swollen belly of the vase, giving it the sensuality of the best examples of the Art Nouveau style.

Iridescence was essential to capturing the essence of a peacock feather, a motif that intrigued Tiffany and which he

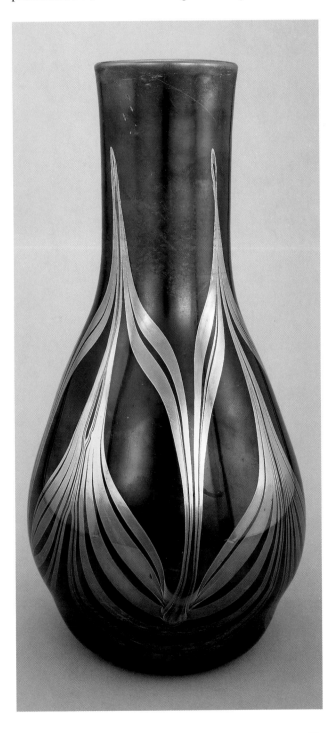

69. Louis Comfort Tiffany. Tiffany Glass and Decorating Company. *Vase*, 1893–96. Favrile glass, h. 14½ in. (36.8 cm). Gift of H. O. Havemeyer, 1896 (96.17.9)

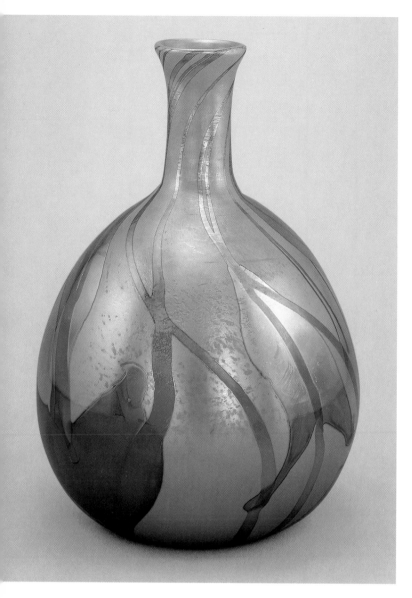

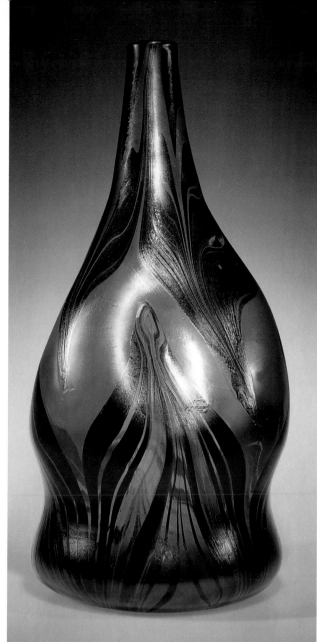

70. Louis Comfort Tiffany. Tiffany Glass and Decorating Company. *Vase,* 1893–96. Favrile glass, h. 9⅛ in. (23.2 cm). Inscribed: (on underside) *X2054.* Gift of H. O. Havemeyer, 1896 (96.17.21)

71. Louis Comfort Tiffany. Tiffany Glass and Decorating Company. *Vase,* 1893–94. Favrile glass, h. 16¾ in. (42.6 cm). Inscribed: (on underside) *X1069.* Gift of H. O. Havemeyer, 1896 (96.17.4)

first achieved so admirably in decorative glass. He used it in some of his most important architectural commissions, including the fantastic overmantel of glass mosaic for the Havemeyer house, the reredos of his chapel at the World's Columbian Exposition, and a leaded-glass window for the Joseph R. DeLamar house on Long Island. Bing, describing Tiffany's interpretation of the motif in 1898, wrote: "Just as in the natural feather itself, we find here a suggestion of the impalpable, the tenuity of the fronds and their pliability.... Never, perhaps, has any man carried to greater perfection

the art of faithfully rendering Nature in her most seductive aspects." The dealer might well have been describing the vase illustrated opposite, perhaps the quintessential example of the type, with a fan shape echoing the peacock's spread plumage (fig. 72). On page 59 one can see Tiffany's development of the motif, from an almost purely naturalistic copy to a more stylized depiction of the "eye" of the feather (fig. 73).

Collectors such as Tiffany, Moore, and Havemeyer appreciated ancient glass not only for its historical value but also for its iridescent surfaces, the result of corrosion from having been buried in the damp earth for centuries. Tiffany best approximated the look of ancient glass in his "Cypriote" vases. Probably the earliest known of this type, the large iridescent vessel shown in figure 74, was given to the Metropolitan in late 1896 and was presumably made earlier that year. The smaller vases most likely date to a decade or two

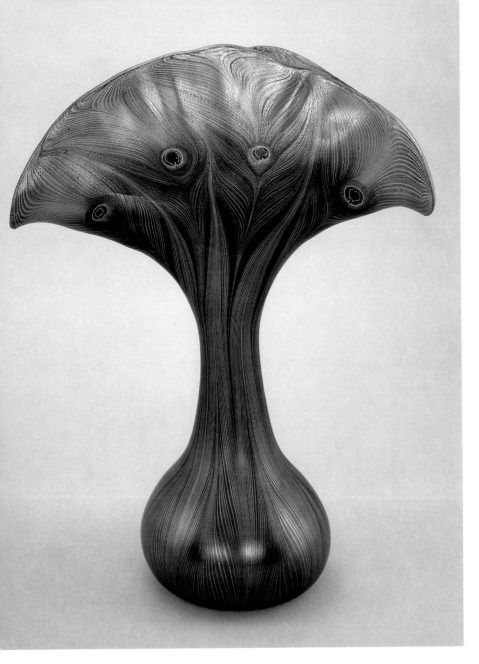

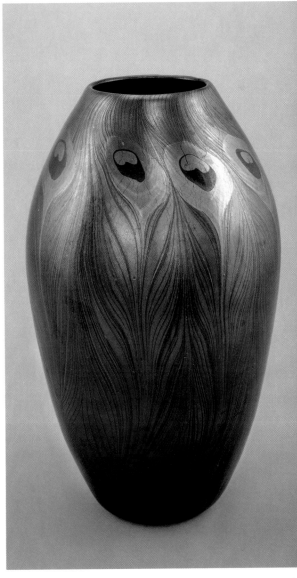

later (fig. 75). Tiffany described them in a memorandum accompanying the loan to the Metropolitan as "reproductions of antique glass," but they are of a more consistent color than their prototypes, primarily of blue or gold, and appear to be more textured. Their crusty, pitted surfaces, made to look like heavy corrosion, were achieved, according to a former Tiffany employee, by rolling the parison of molten glass on a marver covered with pulverized glass crumbs and then exposing the entire surface to metallic fumes to take on iridescence.

Tiffany also looked to antiquity for inspiration for the shapes of his vessels (fig. 76). The vase at the left, with its striking green body, applied cylindrical neck of dark gray - blue, and applied chainlike ornament, belongs to a series of collared glasses with Egyptian-derived decoration on classical shapes. Both this example and the brilliant red one with drawn irregular threads of white glass are strikingly different

72. Louis Comfort Tiffany. Tiffany Glass and Decorating Company. *Vase,* 1893–96. Favrile glass, h. 14 1/8 in. (35.9 cm). Inscribed: (on underside) *o1600.* Gift of H. O. Havemeyer, 1896 (96.17.10)

73. Louis Comfort Tiffany. Tiffany Glass and Decorating Company. *Vase,* 1900. Favrile glass, h. 10 3/4 in. (27.3 cm). Inscribed: (on underside) *Louis C. Tiffany / o7281.* Gift of Louis Comfort Tiffany Foundation, 1951 (51.121.2)

from most of Tiffany's production: they are composed mainly of solid-color opaque glass without the mixing of hues and without opalescence or iridescence.

In addition to ancient Roman, Syrian, and Egyptian glass, Americans were also avidly acquiring sixteenth-century Venetian examples for their display cabinets. Skilled Venetian glassworkers, who jealously guarded their manufacturing secrets, excelled in techniques that imitated other materials, such as agate. Agate glass was first made by the Romans of Alexandria and was further developed by the

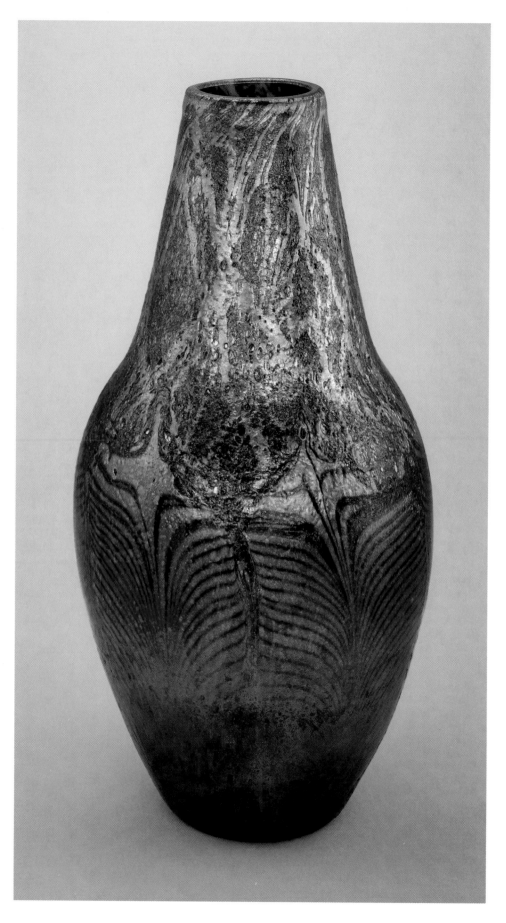

74. Left: Louis Comfort Tiffany. Tiffany Glass and Decorating Company. *Vase,* 1893–96. Favrile glass, h. 11½ in. (29.2 cm). Inscribed: (on underside) *Louis C. Tiffany* [in script] / *L.C.T. D1765.* Gift of H. O. Havemeyer, 1896 (96.17.13)

75. Opposite top: Louis Comfort Tiffany. Tiffany Furnaces. *Vases,* 1912. Favrile glass. Left: h. 4¾ in. (12.1 cm). Inscribed: (on underside) *7247 J. L.C. Tiffany Favrile.* Right: h. 5⅛ in. (13 cm). Inscribed: (on underside) *8319 J L. C. Tiffany Favrile.* Gift of Louis Comfort Tiffany Foundation, 1951 (51.121.7, .4)

76. Opposite bottom left: Louis Comfort Tiffany. Tiffany Glass and Decorating Company or Tiffany Furnaces. *Vases.* Favrile glass. Left: ca. 1900–1915, h. 7⅞ in. (20 cm). Inscribed: (on underside) *L. C. Tiffany—Favrile 6272 E.* Anonymous Gift, 1955 (55.213.13). Right: 1910, h. 5¼ in. (13.3 cm). Inscribed: (on underside) *138 A-coll. L. C. Tiffany—Favrile.* Gift of Louis Comfort Tiffany Foundation, 1951 (51.121.26)

77. Opposite bottom right: Louis Comfort Tiffany. Tiffany Furnaces. *Vase,* 1910. Favrile glass, 3¾ in. (9.5 cm). Inscribed: (on underside) *L. C. Tiffany—Favrile / 105 A-coll. Salon—1906.* Gift of Louis Comfort Tiffany Foundation, 1951 (51.121.23)

Venetians in the late fifteenth century. In Tiffany's version of
the technique, brown, cream, and yellow hues were com-
mingled, producing variegated colors. After the vessel had
cooled and hardened, it was cut in facets to enhance its
stonelike appearance (fig. 77).

Flowers and plants were Tiffany's lifelong obsessions,
whether carefully tended in his lush gardens at Laurelton
Hall or imaginatively captured in glass. There are almost as
many variations of botanical motifs on Favrile works as
there were techniques to display them. Lily pads and Queen
Anne's lace, two of his favorites, are featured in the almost
colorless cut-glass vase shown in figure 78.

Casing and cutting through one or more layers of dif-
ferent colors of glass was practiced early on at Tiffany's fur-
naces. The leading exponent of this work was the firm of
Thomas Webb, in Stourbridge, and Tiffany and Company
showcased their British wares in America. Thomas Webb
was also the training ground for Fredolin Kreischmann
(1853–1898), one of the few craftsmen identified as working
on blown glass for Tiffany. An Austrian glass cutter and
engraver, Kreischmann was hired in 1893 and in the five
years before his death in 1898 was responsible for some of

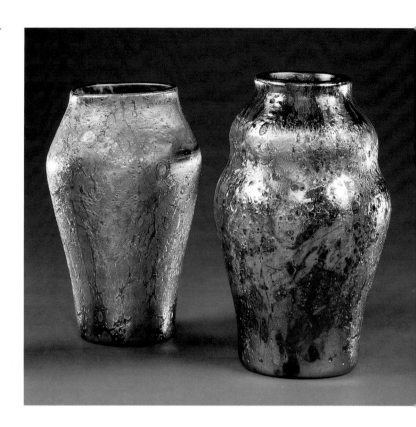

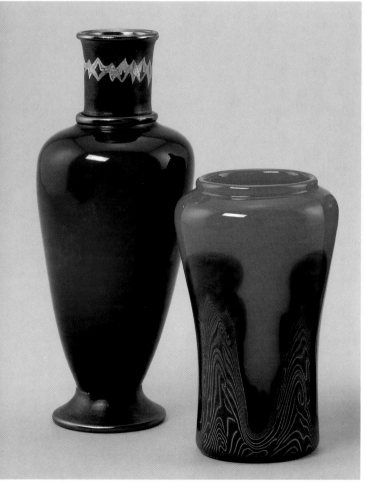

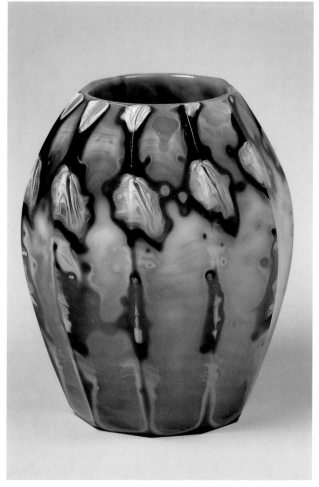

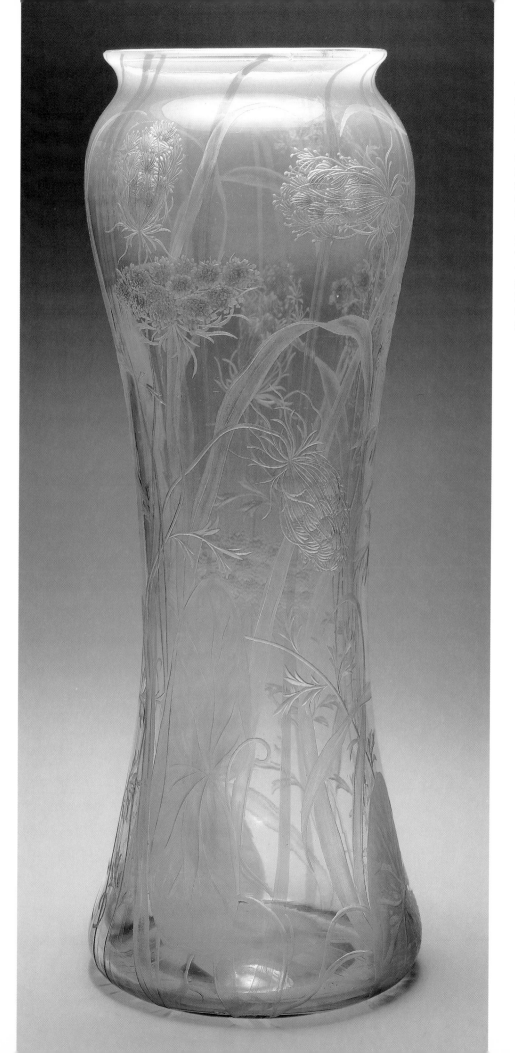

78. Louis Comfort Tiffany. Tiffany Glass and Decorating Company. Probably cut by Fredolin Kreischman[n] (1853–1898). *Vase,* 1895–98. Cased, cut, and engraved Favrile glass, 12¼ in. (31.1 cm). Inscribed: (on underside) *X3027.* Purchase, William Cullen Bryant Fellows Gifts, 1997 (1997.409)

79. Opposite: Louis Comfort Tiffany. Tiffany Furnaces. *Vase,* 1903. Favrile glass, h. 8⅝ in. (22 cm). Inscribed: (on underside) *Louis C. Tiffany R2415.* Gift of Louis Comfort Tiffany Foundation, 1951 (51.121.28)

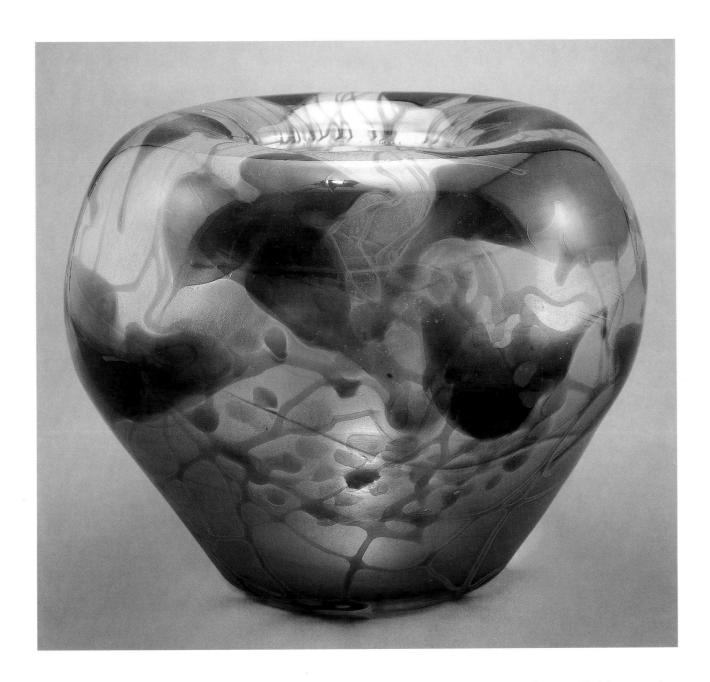

the most breathtaking pieces to emerge from the furnaces. This vase, attributed to him, is subtle, almost evanescent, its colorless body deepening to a pale, pearly blue opalescent at the top of the rim. The lily pads are carved from a light spring green glass applied to the lower part of the vase, with stems of the same color seeming to float to the top of the vessel. The delicate cut blossoms of Queen Anne's lace have been executed in an extraordinarily skillful manner with each minute floret fully articulated, and the blossoms, in different states of maturity, rendered from many different angles. The fluidity of the design belies the laboriousness of its execution. Such work is painstaking and time-consuming (Krieschmann's obituary noted that "he often worked four months on a single piece"), which may account for the small number of cameo-cut vases, as they are called, known today.

The fluid composition of the cut vase is matched by the floating quality of the green leaves and pink berries on the massive vase illustrated above, the result of their being covered with many clear, colorless layers (fig. 79). The vase's ethereal glow derives from being exposed to fumes of metallic oxide that produced the golden iridescence on the interior.

Tiffany's vases in the shapes of flowers are among his most fanciful creations. In traditional glassmaking terms, they are a variation of the goblet. Among the first examples were slender budlike glasses, to which he added metal stems and leaves. Later, all in glass, they took on willowy forms and decoration of leaves, veins, petals, and other characteristics of growing plants. The shapes recall the more whimsical but

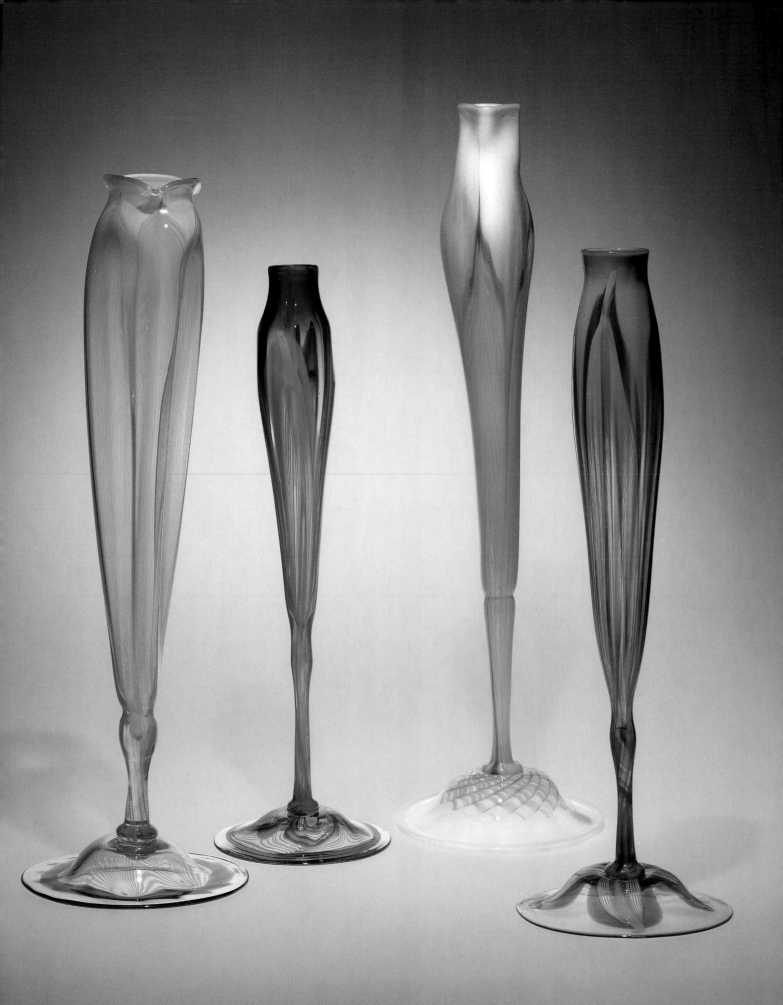

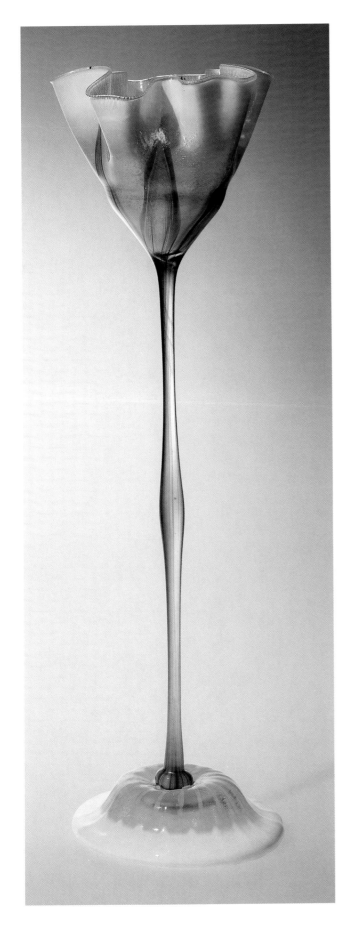

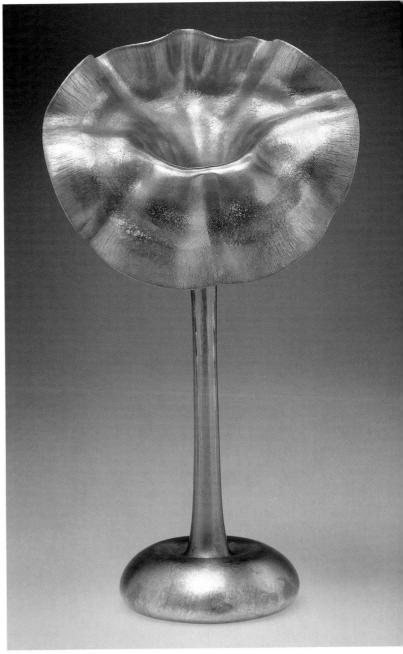

80. Opposite: Louis Comfort Tiffany. Tiffany Glass and Decorating Company. *Vases*, 1893–96. Favrile glass. Far left: h. 14¾ in. (37.5 cm). Inscribed: (on underside) *o1454*. Center left: h. 12¾ in. (32.4 cm). Inscribed: (on underside) *o1218*. Gift of H. O. Havemeyer, 1896 (96.17.38,.41). Center right: h. 16¼ in. (41.3 cm). Inscribed: (on underside) *L.C.T. / M 427*. Anonymous Gift, 1955 (55.213.28). Far right: h. 13⅛ in. (33.3 cm). Inscribed: (on underside) *o1315*. Gift of H. O. Havemeyer, 1896 (96.17.39)

81. Louis Comfort Tiffany. Tiffany Glass and Decorating Company. *Vase*, 1898. Favrile glass, h. 18¾ in. (47.6 cm). Inscribed: (on underside) *L.C.T. T 1269*. Gift of Louis Comfort Tiffany Foundation, 1951 (51.121.17)

82. Louis Comfort Tiffany. Tiffany Glass and Decorating Company or Tiffany Studios. *Vase*, 1900–1915. Favrile glass, h. 16 in. (40.6 cm). Inscribed: (on underside) *L.C.T. 155 A*. Gift of Helen Palmer Andrus, in memory of Helen Andrus Pinkham, 1997 (1997.206)

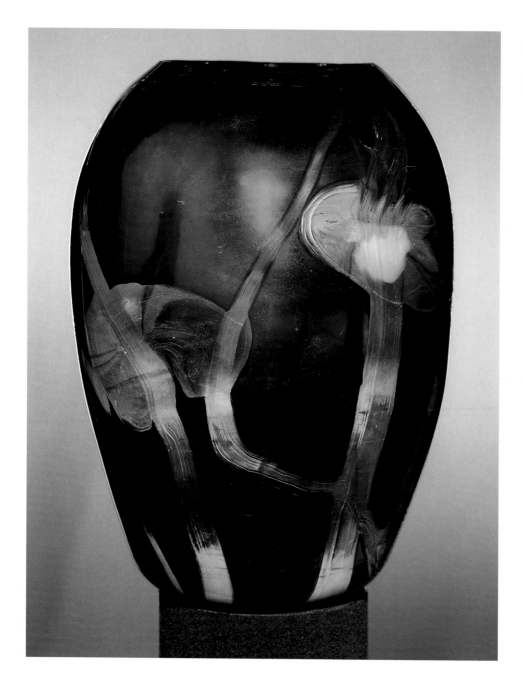

83. Louis Comfort Tiffany. Tiffany Glass and Decorating Company. *Vase*, 1897. Favrile glass, h. 11¼ in. (28.6 cm). Gift of Louis Comfort Tiffany Foundation, 1951 (51.121.8)

equally delicate Venetian glasses originally produced in the sixteenth century and revived in the mid-nineteenth century. They also parallel the fragile plant-form vases by the German Karl Koepping, who was represented by Bing in Paris. The narrow-mouth vases shown on page 64 are typical of most of Tiffany's earliest work in this genre (fig. 80). They resemble elongated buds ready to burst into bloom, and the color harmonies range from shades of green to reds and white. Later Tiffany expanded and lightened the palette of his vases and gave them a freer form, like that of the exuberant open blossom shown in figure 81. The warm golden iridescence of the interior makes it seem as if the flower possesses its own internal golden light. Mrs. Robert W.

de Forest owned about twenty such vases, which she displayed in a bow window of the library of her New York townhouse. In describing them, she wrote: "I call this collection my flower garden."

One of the quintessential shapes in Tiffany's blown glass was the so-called jack-in-the-pulpit (fig. 82). Essentially a flower form, it has a flattened globular base resembling a bulb rising into a slender stalk to an open blossom with a ruffled rim. Tiffany confined this type of vase to one color, gold, seen here, or blue, to which he gave an overall iridescence. The outer rim has a feathery appearance, as if when the molten blossom was expanded to its final form the iridescence on the surface developed shallow fissures.

An unusually large dark vase with a striking floral abstraction was among Tiffany's personal favorites (fig. 83). He chose it to be one of the few colorplates in the limited-edition biography, *The Art Work of Louis C. Tiffany*, that he and his family commissioned anonymously in 1914 from Charles de Kay, and in 1925 he selected this vase for loan to the Metropolitan. In the book and in his note accompanying the loan he described it, briefly, as "black body of soft texture with blue iridescent decoration suggesting Iris." The iris is shown as simply a suggestion of a blossom, viewed perhaps from above, looking straight down into it. The subtle wave of the leaves lends the design a sensuous quality that contrasts with the solidity of the vessel's shape. The vase displays some of the special characteristics of Tiffany glass in changing light. In reflected light it appears to be a soft charcoal color, with a matte, slightly iridescent surface and decoration of a strong metallic peacock blue. Transmitted light transforms the vase: the body metamorphoses into a very dark green, and the decoration into a mottled arrangement of earthy colors.

The large open bowl below is as forward-looking in its organic irregular shape (fig. 84) as were Ohr's eccentric,

hand-thrown red earthenwares. Its free form gives the appearance of having been dictated by the movement of the molten glass. Of a type called Lava, or "volcanic," glass, it manifests the characteristic rough, blackened areas made by introducing bits of basalt or talc into the molten material. Portions of the piece were then decorated with heavy applications of gold-luster glass. This bowl is perhaps the most extraordinary of all of Tiffany's Lava vessels. Its broad, smooth areas of gold vividly recall the hot molten rock spilling from the rim of a volcano. Such optical effects, achieved by ingenious techniques that used texture, color, and layering to react to different lighting conditions, give Favrile glass its sumptuousness and vitality.

84. Louis Comfort Tiffany. Tiffany Furnaces. *Bowl*, 1908. Favrile glass, h. 6⅝ in. (16.8 cm). Inscribed: (on underside) *21 A / L. C. Tiffany—Favrile.* Gift of Louis Comfort Tiffany Foundation, 1951 (51.121.13)

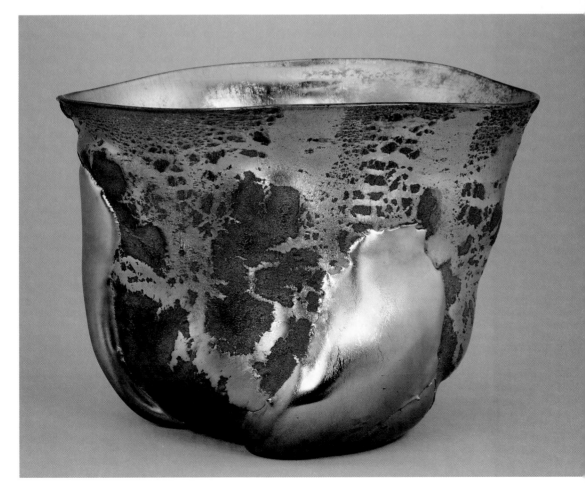

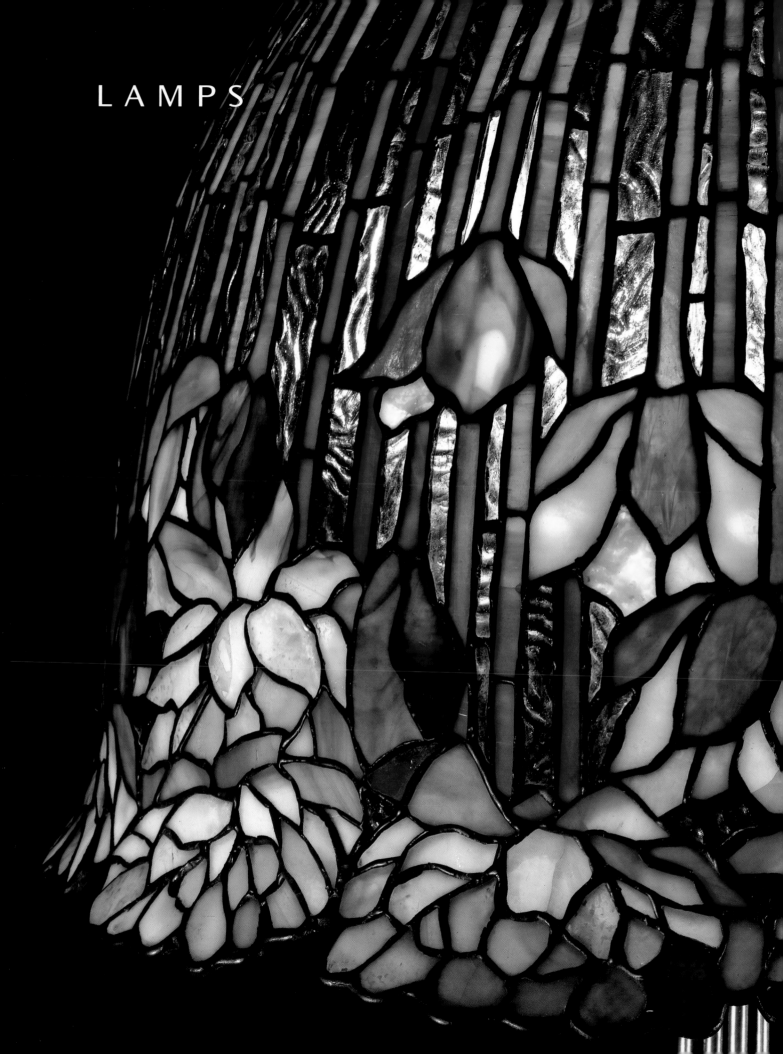

LAMPS

Tiffany's lifelong fascination with light led him to make innovations in stained glass and to find new ways to incorporate electric lighting into his designs. Beginning in 1885, with his work on the Lyceum Theatre in New York, Tiffany pioneered the artistic adaptation of the lightbulb. Five years later he created distinctive metalwork and blown-glass electric light fixtures for the Havemeyer home, but it was not until 1899 that he introduced his first table lamps with bulbs shielded by colorful leaded-glass shades.

The majority of Tiffany lampshades were essentially leaded-glass windows wrapped around a light source. Composed of intricate arrangements of semitranslucent pieces, they were perfect complements for early electric bulbs, shielding the eyes from the bright light and directing it downward. They provided soft illumination inside a delightfully artistic object.

Although designed and constructed in much the same way as the windows, the shades differed in that each was assembled on a solid wooden form on which was delineated the arrangement of the individual pieces of glass (see fig. 87). This method produced a certain amount of conformity among the Studios' shades. The degree to which they varied depended upon the palette and the different kinds of glass selected. Each artisan needed a painter's sense of color to balance the multitude of subtle chromatic nuances, as he or she selected and joined hundreds of pieces into complex compositions.

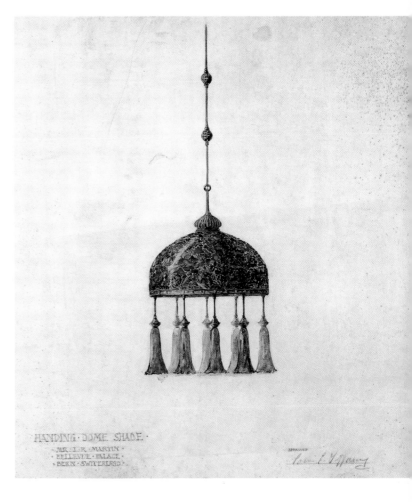

85. Opposite: Detail, *Water-lily table lamp* (see fig. 95)

86. Louis Comfort Tiffany. Tiffany Studios. *Design for magnolia hanging dome shade,* ca. 1905–15. Watercolor on board, 23¾ x 19¾ in. (60.3 x 50.2 cm). Inscription: (lower left) *HANGING DOME SHADE / MR. J. R. MARTIN / BELLEVUE PALACE / BERN / SWITZERLAND;* (lower right) *Approved* / [signed] *Louis C. Tiffany.* Purchase, Walter Hoving and Julia T. Weld Gifts and Dodge Fund, 1967 (67.654.199)

87. Lamp Department, Tiffany's Corona workshops, Queens, New York, with artisans assembling leaded-glass shades on wooden molds. Published in *Cosmopolitan,* January 1899. Photograph courtesy of J. Alastair Duncan Ltd.

By 1906 over 125 designs for shades could be ordered from Tiffany Studios. Prices ranged from $30 for lamps with small geometric-shaped shades to as much as $750 for the most elaborate floral patterns. Even at the lower price range, the lamps were considered luxury goods. It took a skilled worker as long as a week just to choose and cut the myriad pieces of glass.

For custom-made lighting, several sketches might be drawn using two different schemes. One such design, for a domed magnolia hanging lamp with blown-glass trumpet shades, was made for the Bellevue Palace, a luxury hotel in Bern, Switzerland (fig. 86). The other choice presented to the client incorporated elaborate peony blossoms in tones of red and deep pink with green foliage. Once the composition was approved, it was translated into a watercolor cartoon. A straight-sided shade, such as these dragonfly and poppy examples, was rendered in a flat, open pattern with

88. Opposite top: Louis Comfort Tiffany. Tiffany Glass and Decorating Company or Tiffany Studios. *Working drawing for dragonfly shade,* ca. 1899–1905. Watercolor, graphite, black ink, and white gouache on paper mounted on board, 11⅞ x 21⅞ in. (30.2 x 55.6 cm). Purchase, Walter Hoving and Julia T. Weld Gifts and Dodge Fund, 1967 (67.654.464)

89. Opposite bottom: Louis Comfort Tiffany. Tiffany Glass and Decorating Company or Tiffany Studios. *Working drawing for poppy shade,* ca. 1900–1915. Watercolor, graphite, and black ink on paper; shaped sheet 12¼ x 19¾ in. (31.1 x 50.2 cm). Purchase, Walter Hoving and Julia T. Weld Gifts and Dodge Fund, 1967 (67.655.7)

90. Above: Louis Comfort Tiffany. Tiffany Glass and Decorating Company or Tiffany Studios. *Working drawing for fruit shade,* ca. 1900–1915. Watercolor and graphite on linen cloth mounted on board, 15⅝ x 12⅝ in. (39.7 x 32.1 cm). Inscription: (on mount, lower right) *24" Fruit Shade.* Purchase, Walter Hoving and Julia T. Weld Gifts and Dodge Fund, 1967 (67.654.225)

91. Right: Louis Comfort Tiffany and Adrien-Pierre Dalpayrat (1844–1910). *Table lamp with shade,* 1900–1902. Shade designed by Louis Comfort Tiffany, Tiffany Studios, New York City. Glass, glazed stoneware, bronze, h. 23½ in. (59.7 cm). Shade marked: (stamped on inside edge) *TIFFANY STUDIOS NEW YORK.* Gift of Ruth and Frank Stanton, 1981 (1981.495.2)

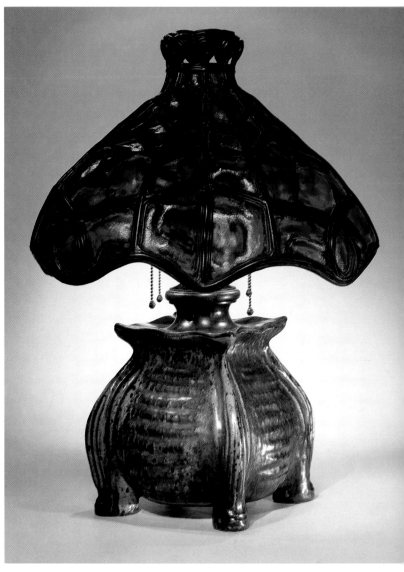

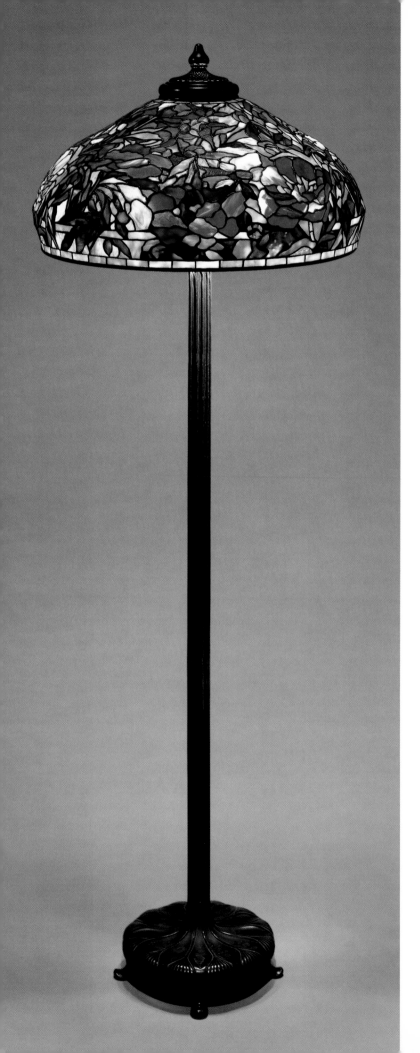

thick dark outlines indicating placement of the leading (figs. 88, 89). The cartoons often show only a section of the design, which was repeated around the shade. A curved shade required additional cuts so that it could be joined on the model (fig. 90). Then another uncolored outline drawing was made and keyed by numbers to metal templates that served as the patterns for cutting the glass pieces. Following the general color scheme of the large paper or cloth pattern affixed to the wooden form, the craftsman painstakingly joined the pieces with copper foil and lead solder.

An early experimental and unique lamp combines a Tiffany glass shade with a French pottery base by Adrien-Pierre Dalpayrat (1844–1910; fig. 91). The base appears in photographs taken in 1900 of Siegfried Bing's influential Paris gallery L'Art Nouveau, and the lamp was probably assembled shortly thereafter. The unusual shade is made of large turtle-back glass tiles joined by heavy milled leading. The harsh red color has been muted by black paint applied to the underside of the shade, giving it a mottled effect that complements the glaze of the ceramic base. Although Tiffany preferred bronze bases of his own making, for a few of his commercial lamps he paired his shades with bases from the Grueby Pottery in Boston.

Many of Tiffany Studios' lamp designs were adaptations of motifs from Tiffany's windows—flowers, fruit, blossoming vines, and trees. The spring flowers—wistaria, magnolia, and peony—were among his favorites. The magnolia could be interpreted successfully in opalescent glass, with its creamy tints of pink, purple, or blue. The peony inspired two different shades, the more elaborate of which is a large domed shape on a floor standard (fig. 92). Its brightly colored blossoms, which vary slightly in color around the lamp in hues ranging from pale pink to deep red, burst forth from verdant leafy foliage, the size and shape of the individual pieces of glass mimicking the actual petals and leaves of the flower itself. A floral table lamp proposed for Miss H. W. Perkins with spring-flowering white dogwood blossoms on the shade and a slender trunk or branch base is reminiscent of the Museum's dogwood window (fig. 94).

One of Tiffany's most effective floral shades is the extraordinary water-lily table lamp, with its subtly toned blossoms cascading from the shade crown to its irregular border formed by creamy-color-tinged petals (fig. 95). A variety of glass was used to great advantage, especially in the alternation of the pink opalescent stems with those of translucent rippled blue, giving the appearance of a bog

92. Louis Comfort Tiffany. Tiffany Studios. *Peony shade with standing lamp,* 1904–15. Leaded Favrile glass and bronze, diam. (of shade) 22 in. (55.9 cm). Stamped: (on shade) *TIFFANY STUDIOS NEW YORK 1908;* (on base) *Tiffany Studios NEW YORK 379.* Bequest of Helen R. Bleibtreu, 1985 (1986.81.1)

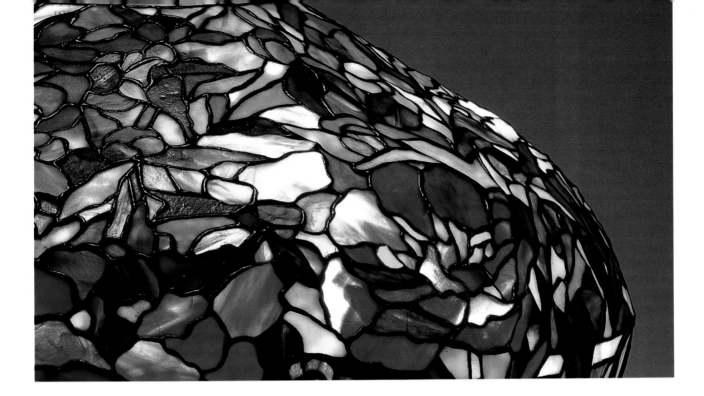

93. Detail, *Peony shade*

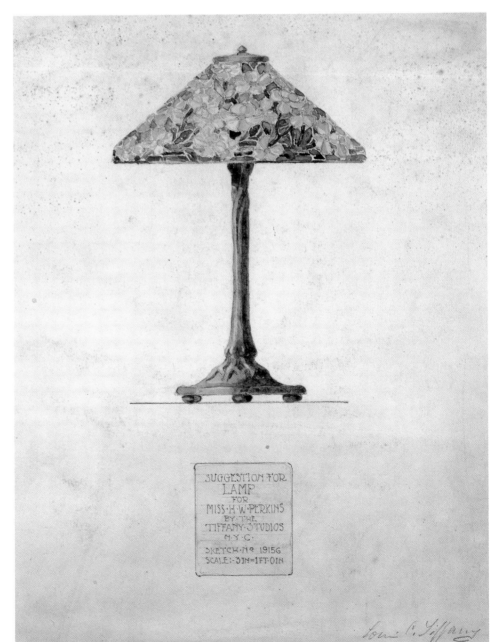

94. Louis Comfort Tiffany. Tiffany Studios. *Drawing for Miss Perkins's lamp*. Watercolor and graphite, 15¼ x 12¾ in. (38.7 x 32.4 cm). Inscriptions: (in cartouche, centered below image) *SUGGESTION FOR / LAMP / FOR / MISS H. W. PERKINS / BY THE / TIFFANY STUDIOS / NYC / SKETCH NO. 1915G / SCALE: 3 IN. EQUAL 1 FT. 0 IN.;* (signed, lower right) *Louis C. Tiffany*. Purchase, Walter Hoving and Julia T. Weld Gifts and Dodge Fund, 1967 (67.654.2)

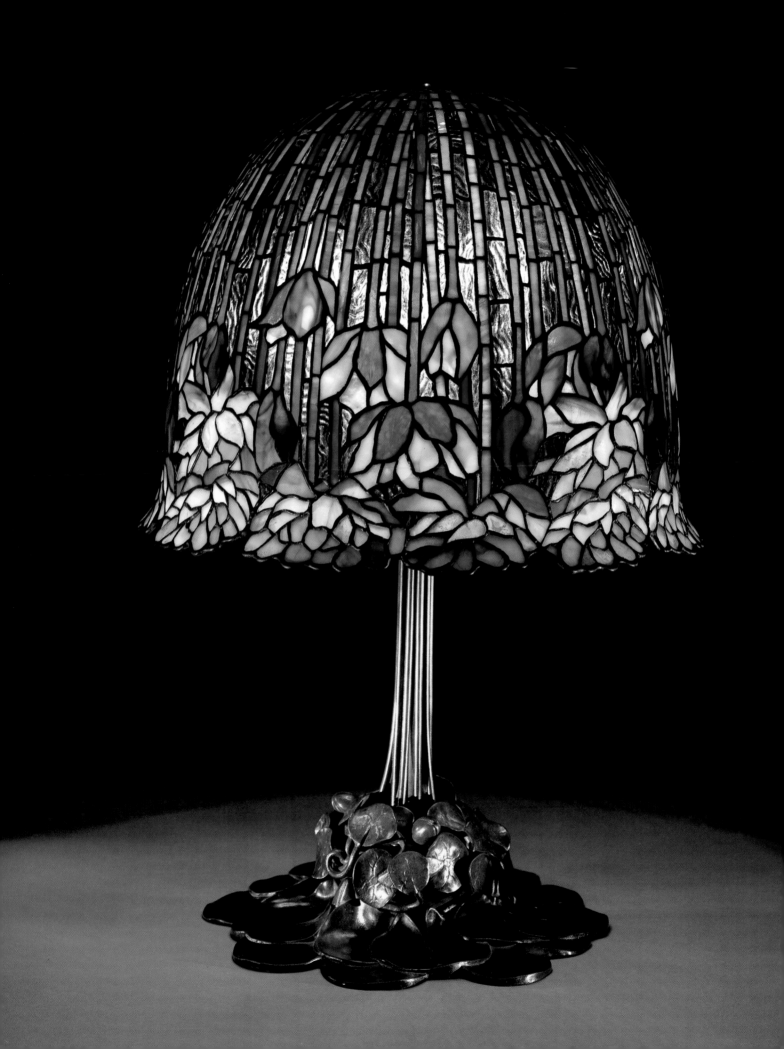

95. Opposite: Louis Comfort Tiffany. Tiffany Studios. *Water-lily table lamp,* 1904–15. Leaded Favrile glass and bronze, h. 26½ in. (67.3 cm). Gift of Hugh J. Grant, 1974 (1974.214.15a,b)

96. Louis Comfort Tiffany. Tiffany Glass and Decorating Company. *Indian basket hanging shade,* ca. 1899. Leaded Favrile glass, h. 14⅞ in. (37.8 cm). Gift of Mr. and Mrs. Douglas Williams, in memory of Mr. and Mrs. Robert W. de Forest, 1969 (69.150)

where water lilies might be found. The organic character of the lamp is accentuated by the bronze support, which replicates broad, flat lily pads clustered around a base with climbing stems that disappear into the blossomed shade. Although this base design was used with other floral lamps, nowhere is it better suited to its shade than here.

A shade in the shape and design of an American Indian basket was a novel idea of Tiffany's (fig. 96), undoubtedly evolving from his interest in hand-workmanship and use of natural materials. Tiffany avidly collected Native American

baskets, as did his close friend and associate Robert W. de Forest, for whom this unusual hanging lamp was made. It originally hung in a great walnut-paneled hall lined with such baskets in de Forest's Long Island home. Only one other version of the shade is known.

Despite their great appeal, Tiffany remained ambivalent about his lamps. The leaded-glass shades were left out of his lavish biography by Charles de Kay, which included every other medium in which he worked. His plan of designing unique decorative objects for the home conflicted philosophically with the manufacture of his shades in multiples. The patterns, models, and increasing volume of orders led to uniformity, and the dichotomy of the reproduced object and the ideal of a unique work of art must have been difficult for Tiffany to reconcile in his role as a creative artist.

ENAMELS AND CERAMICS

ENAMELS

Tiffany's work in enamels was a logical extension of his efforts in stained glass: enameled objects are essentially made of glass and glass silicate colored with metallic oxides that are applied to copper or other metals and then fired at high temperatures. Despite the connection between the two, few American glassmakers experimented in this medium. Among the revivals in the arts and crafts, enameling was not embraced to the extent that other techniques were, especially in America. Prior to Tiffany's endeavors, however, enameling was used mainly on jewelry, with Tiffany and Company a leader in the field, producing exquisite designs with subtle colorful details.

Tiffany's experiments began in 1898, initially in a workshop in his Madison Avenue home. He then moved his operations to his Twenty-third Street headquarters, and in 1903 to his own shop, then called Tiffany Furnaces, at Corona, Queens. His enamels were primarily translucent, with a golden luminescence. To achieve this effect, before he brushed his glass colors onto the copper surface, Tiffany applied a layer of gold or silver foil over a thin coat of enamel, which would reflect light through the successive colors. Iridescence was attained by spraying a mixture of tin chloride and water or alcohol on the surface. Instead of using traditional opaque colors in a limited range, separated by tiny metal strips, as in the cloisonné or champlevé techniques, Tiffany broadened his palette by painting directly on the prepared surface, layering the translucent colors, as he did in plating his stained glass, to achieve different hues. His enamels, among the earliest of which were lamp bases, were first exhibited publicly at the 1900 Exposition Universelle in Paris, where their iridescence was highly acclaimed. The enameling department was small and production limited— probably not exceeding 750 pieces—and was staffed primarily, if not exclusively, by women. Patricia Gay headed the operation at the beginning and worked there for about two decades. Julia Munson (1875-1971), a talented member of the team, was assisted by Alice C. Gouvy, who, as evidenced by several signed drawings, was one of the principal designers. She took charge of the department when it moved to Tiffany Furnaces.

The department produced primarily decorative vases, bowls, and covered boxes. The ornamentation varied widely, from patterns created by the enamel itself on an otherwise smooth surface to more unusual, deep repoussé floral, vegetable, and fruit motifs, literally hammered into the metal before enamels were applied.

Both the plum bowl and the tall corn vase are large compared with the majority of Tiffany's enamels and were

97. Opposite: Detail, *Bowl*

98. Louis Comfort Tiffany. Tiffany Glass and Decorating Company. *Bowl*, 1899. Enamel on copper, w. 9½ in. (24.1 cm). Signature and inscription: (on underside) *SG44 / Louis C. Tiffany*. Gift of Louis Comfort Tiffany Foundation, 1951 (51.121.29)

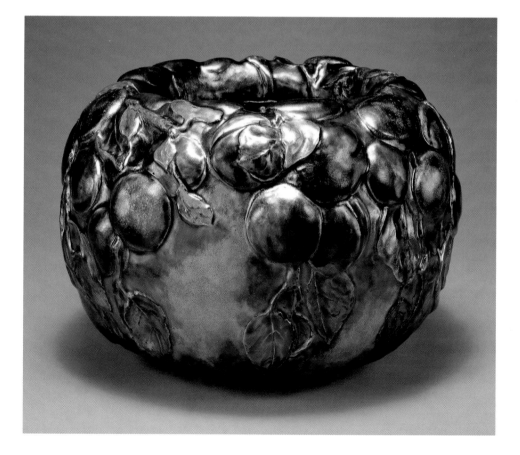

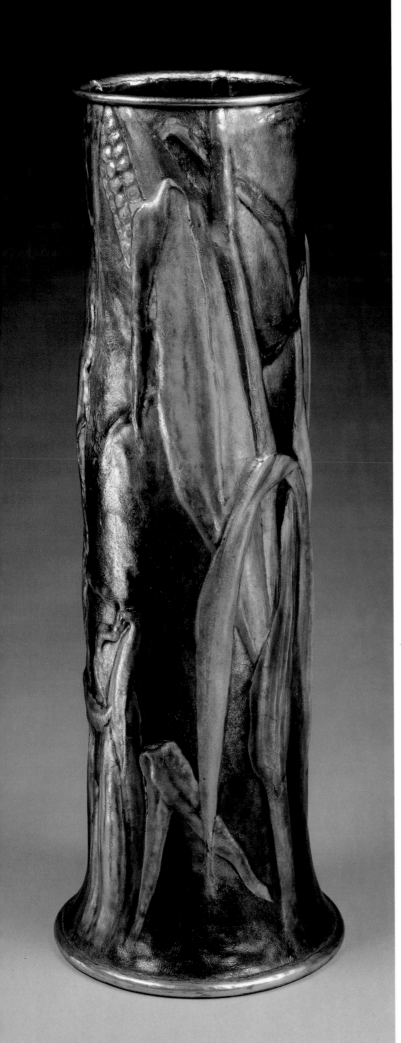

probably made between 1898 and 1902. The shape of the bowl alludes to the plump, rounded form of a ripe plum (fig. 98). Fruit, leaves, and branches are rendered in repoussé in high relief, and the plums are so three-dimensional that they look almost as if they could be plucked off the bowl. Covered in a deep purple enamel, the surface of the plums varies as light hits it, giving it an iridescent sheen reminiscent of Tiffany's glass. Heavily laden with overlapping fruit, the branches cascade over the sides of the vessel. Leaves are especially finely delineated in repoussé, with veining accentuated by tooling. The richly textured exterior contrasts with the shiny, smooth finish of the green interior. Like that of the corn vase, the shape is related to those found in Tiffany's ceramics just after 1900 (see fig. 104).

The almost cylindrical corn vase is softened by repoussé, adding dimension to the ears and stalks (fig. 99). These details are bold in conception, with extraordinary attention given to the leaves, which appear ribbed with slightly ruffled edges. The verticality of the vase is accentuated by the thick, nearly straight stalks that rise from base to rim. Gold leaf shows through the translucent enamel finish, providing a richly colored surface to which the enamels adhere. The subtle, natural, translucent colors range from the golden hues of the ears to the delicate greens and yellows of the foliage. The soft, semimatte shaded exterior contrasts sharply with the bright, solid blue of the opaque enamel coating the interior.

The decoration on the covered shallow box is much subtler (fig. 100). The high-relief, heavy repoussé forms and smoothness of the earlier enamels have given way to a lightly textured hand-hammered surface. The grasshopper resting on a slender blade of grass recalls motifs and compositions made popular by Japanese prints, of which Tiffany had a sizable collection. Tiny green star-shaped leaves and orange berries shaped like coffee beans enliven the composition of the insect on a dark gray background. A thin coat of pearly salmon-pink enamel, which emulates lustrous Japanese tea papers, lines the interior.

The rectangular jewelry box—one of only two by Tiffany known in this medium—is a skillful combination of

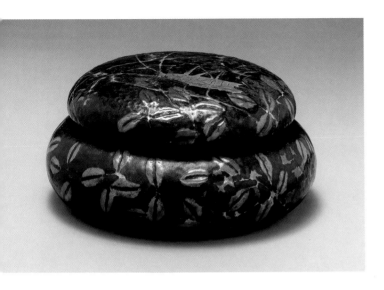

enamel and Favrile glass (fig. 101). Glass blown into the metal framework formed convex shapes inside the bronze supporting the glass, providing background for the composition and delineating the design of cherries, leaves, and branches. The bronze also serves as a base for the copper plating, to which the enamel was applied, coloring fruit and leaves. The glass was exposed to metallic fumes to achieve iridescence. In certain lighting conditions it appears as a pearly gold background and in others as a pale blue-green sky.

Each side of the box displays an appealing configuration of fruit and branches. The top features an asymmetrical composition: a thick branch spans the diagonal, serving both as a design element and as a handle. Evidence of handworking

can be seen in the rough-hammered surface of the bronze branches, which are patinated for a naturalistic appearance.

The enameling department at Tiffany Furnaces ceased operations about 1907, although enameling was continued in jewelry production at Tiffany and Company. As an indication of his esteem for his enamels Tiffany kept a number of examples for his own collection and placed them on view at the Metropolitan in 1925, at the time that he loaned his Favrile glass vases.

CERAMICS

A few years after Tiffany had mastered the complex technique of enameling, he began to produce ceramics. His inspiration came from French examples he saw in 1900 at the Exposition Universelle, where, as reported by the American porcelain artist Adelaide Alsop Robineau, "he had been so charmed with the work of artist potters. . .that he came home with determination to try it." The ceramics to which he was most attracted, and which he would later exhibit in his own showrooms, were the luster wares of Clément Massier and the unusual crystalline-, flambé-, and aventurine-glazed examples by Dalpayrat, Auguste Delaherche, and Alexandre Bigot.

The 1876 Centennial Exhibition in Philadelphia sparked a rage in America for oriental design, particularly for things Japanese, and by the 1880s a number of individuals, Colman and Havemeyer among them, were amassing collections of Japanese and Chinese ceramics. To see French art pottery

101. Louis Comfort Tiffany. Tiffany Glass and Decorating Company. *Covered box*, 1898–1902. Favrile glass and enamel on copper, w. 6 in. (15.2 cm). Signature and inscription: (on underside) *S G 900 / Louis C. Tiffany.* Gift of Louis Comfort Tiffany Foundation, 1951 (51.121.42a,b)

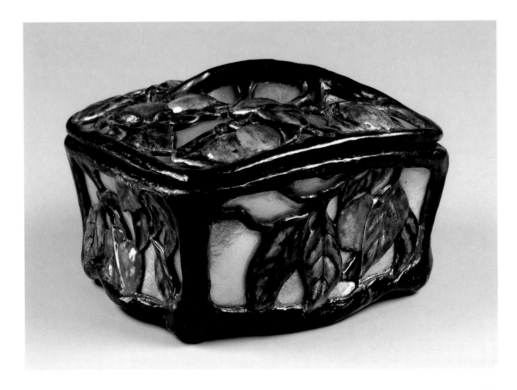

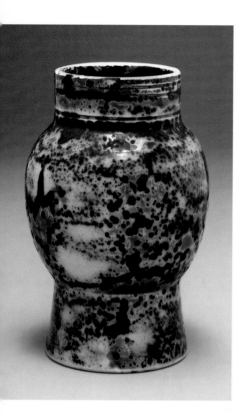

102. Louis Comfort Tiffany. Tiffany Glass and Decorating Company. *Vase,* ca. 1901–1902. Glazed earthenware, h. 4⅝ in. (11.8 cm). Inscribed: (on underside) *181A-Coll. L. C. Tiffany–Favrile Pottery /* conjoined *LCT/B.* Gift of Louis Comfort Tiffany Foundation, 1951 (51.121.21)

103. Louis Comfort Tiffany. Tiffany Studios. *Vase,* ca. 1904–14. Glazed earthenware, h. 10⅞ in. (27.6 cm). Inscribed: (on underside) conjoined *LCT / 7 / P1261 / L. C. T. Favrile Pottery.* Promised gift of an anonymous donor (L.1979.137.5)

Tiffany had to travel to Paris, as little of it was exported to the United States. No doubt he first viewed examples at the opening in 1895 of Bing's gallery L'Art Nouveau, which featured works by modern French potters along with Tiffany's own Favrile glass vases.

The Museum's small symmetrical vase is a fine example of Tiffany's ceramics, dating probably to 1901 or 1902 (fig. 102). The piece is roughly cylindrical with a bulbous midsection reminiscent of Chinese wares. Its smooth sides are especially suitable for the unusual glazing that Tiffany called a "delicate color reaction." Here, the hard, almost porcelaneous surface is speckled with deep flambé red, black, and green, a glaze closely resembling that used by French potters, Dalpayrat in particular (see fig. 91).

Many of Tiffany's pottery vases derived their forms from common wildflowers and water plants as they look in their natural habitats—ferns, lilies, cattails, jack-in-the-pulpits, and toadstools—and were less stylized than the attenuated Art Nouveau forms by European ceramicists. One such vase, although essentially cylindrical, is composed of the blossoms, buds, leaves, and stems of a poppy, resulting in an irregularly shaped rim and an openwork portion at the top (fig. 103). Complex designs such as this owe less to contemporary French pottery than to Danish porcelains of the same period, notably those by the Bing and Grøndahl factory in Copenhagen.

The poppy was a favored motif for turn-of-the-century artists, not only for the expressive possibilities of the plant

itself but also for its association with the dreamlike state induced by opium. Although the flower was often used to symbolize night, the plant is here depicted in its complete life cycle: in bud, in full bloom, and gone to seed.

To accentuate the relationship of his subjects to nature, Tiffany sheathed some of his vases—including the poppy—in soft, matte-green glazes, ranging from light yellow-green to cool blue-green, that flowed irregularly over the molded surface. These glazes recall those on art pottery made by Grueby in Boston, the first and most prolific producer of

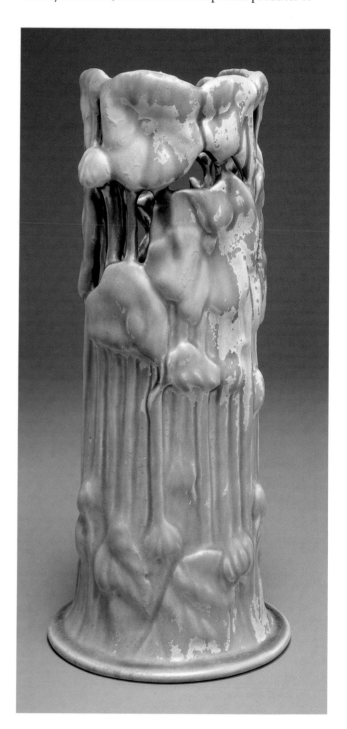

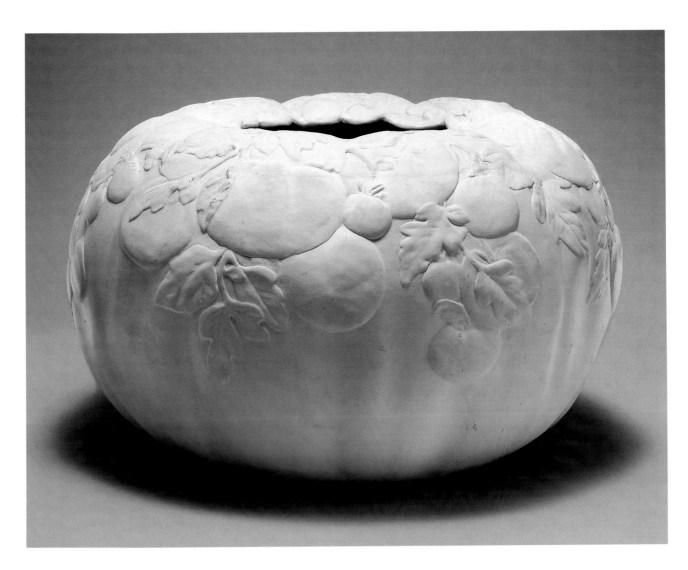

104. Louis Comfort Tiffany. Tiffany Studios. *Tomato vase*, ca. 1904–14. Glazed white earthenware, w. 13½ in. (34.3 cm). Incised: (on underside) conjoined *LCT*. Gift of Paul and Chloe Nassau, 1996 (1996.452)

matte-green glazed wares. In addition, crystalline effects, varying from light to dark green and resembling the colors of moss and lichen on the forest floor, were introduced by European potters by 1908. Tiffany also used glazes in a cream color tinged with ocher, which gave the appearance of antique ivory.

Tiffany turned out a few vases with glazed interiors but unglazed exteriors. Although such vessels may appear to be unfinished, the number of examples treated in this manner suggests that they were left bare intentionally to reveal fully the relief on the exterior. An apt example is the Museum's large vase illustrated above (fig. 104). The squat, lobed tomato shape bears carefully articulated low-relief vines and fruit around the upper part. The crisp, marblelike white surface enhances the sculptural effect of the vessel and contrasts with the dark green glaze of the interior. Some light

brown areas on the exterior may be the result of overfiring. The form of the vase duplicates one produced in enamel on copper, the drawing for which, of tomatoes on a vine, is signed by Alice C. Gouvy.

Somewhat uncharacteristic in Tiffany's oeuvre, his pottery vases were not handcrafted, unique objects; rather, they were usually cast in molds. From a hand-formed model made from a design approved by Tiffany, a plaster mold was produced, and a limited number of vessels were slip cast. The plasticity of the clay gave him freedom to create a wide range of sculptural effects. Cast vases derived their individuality from the glazes. Despite this method of manufacture, Tiffany's output of pottery was relatively small.

The first public showing of Tiffany's "Favrile" pottery, as it was called, was at the 1904 Louisiana Purchase Exposition. Soon afterward it was offered for sale at Tiffany and Company and was included in the *Blue Book*, the catalogue for their preferred customers. The Studios produced pottery for only about a decade, closing their kilns around 1914.

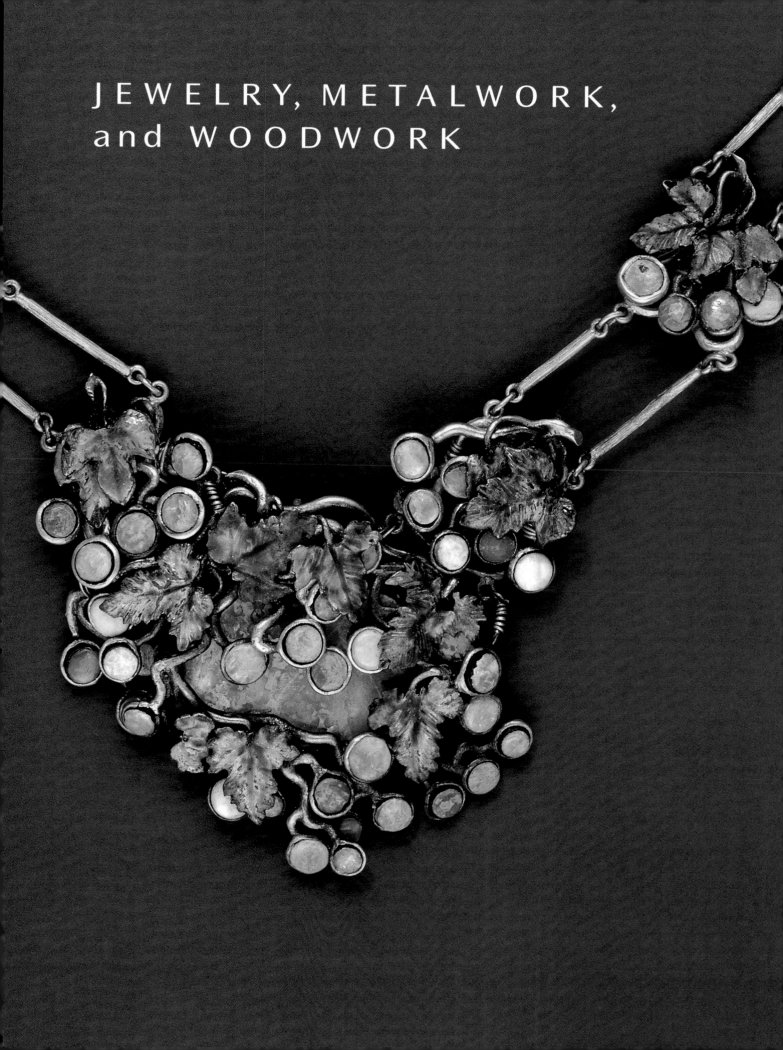

JEWELRY, METALWORK, and WOODWORK

JEWELRY

After his father's death in 1902, Louis Tiffany became the artistic director of Tiffany and Company. His familiarity with jewelry manufacturing at the firm, as well as the collaboration with his father on several pieces for the Paris Exposition Universelle in 1900, undoubtedly inspired him to produce jewelry at his own workshops on Twenty-third Street. His earliest pieces, including the grape-cluster necklace and the dragonfly-and-dandelion hair ornament, were made there when Tiffany began experimenting, in much secrecy, with the design and fabrication of jewelry. He intended to introduce his work at the 1904 Louisiana Purchase Exposition in St. Louis.

Tiffany broke new ground at the Studios, using semiprecious stones—opals, moonstones, garnets, amethysts, and coral—in contrast to the precious gems set in pieces by Tiffany and Company. The semiprecious stones embodied the properties that Louis Tiffany valued in other media. For example, the milky quality of moonstones resembled the opalescence of his glass, and the fiery glow of opals, the rainbow iridescence of Favrile vases. Tiffany set the stones in novel and inventive ways, often in combination with enamels. The brilliant translucence of the enamels complemented the luminescence of the stones for a colorful effect similar to that of his light-filled stained-glass windows. Tiffany was also one of the earliest jewelers to use platinum, a metal new to the industry at the turn of the century.

Unlike the more formal jewelry made by Tiffany and Company during the first decades of this century, Louis Tiffany's pieces were characteristically asymmetrical, with fluid lines and organic shapes, which were expressive of his desire to replicate natural forms in exotic materials. The motifs further demonstrate his fondness for insects and plants, particularly uncultivated varieties, such as Queen Anne's lace, blackberries, dandelions, and wild grape—all images also seen in his windows and lamps. The dragonfly was featured on a number of different pieces, and in one instance he paired a peacock and a pink flamingo on a necklace pendant. Tiffany's jewelry was generally restrained in color, combining one or two hues with subtle variations. Design and craftsmanship were more important to him than opulence.

One of the earliest examples of Tiffany's jewelry is a necklace composed of a series of grape clusters and leaves. Tiny circular black opals represent the fruit, and enameling in shades of green on gold forms the delicate shimmering leaves (fig. 106). The finely executed enamel and gold reveal the handwrought character of the jeweler's craft. Tiffany chose the necklace as one of the twenty-seven pieces to be made for the Louisiana Purchase Exposition, and it is the

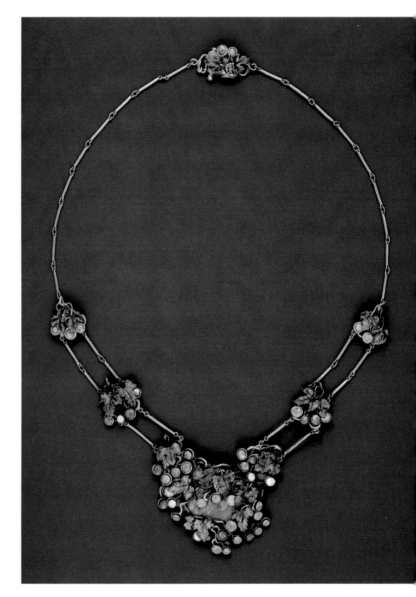

105. Opposite: Detail, *Necklace*

106. Louis Comfort Tiffany. *Necklace,* ca. 1904. Opals, gold, and enamel, l. 18 in. (45.7 cm). Gift of Sarah E. Hanley, 1946 (46.168.1)

only one of those exhibited known to survive. In a contemporary photograph of several items in the display the central pendant of the large opal partially obscured by grapes and leaves is smaller than it is now (fig. 107): a grape cluster was added on each side at a later, unknown date. Moreover, the same photograph shows that the small grape clusters were originally strung together on a single, threadlike gold chain. The necklace was also altered at a later date, probably at the same time as the pendant, by the addition of the double barlink chain, which gives the whole stronger support. Tiffany probably directed the changes himself, as the necklace came to the Museum from Sarah E. Hanley, his nurse and later companion, to whom he must have presented it.

TIFFANY & CO. EXHIBIT
LOUISIANA PURCHASE EXPOSITION
ST. LOUIS 1904 L.C.T. NEG. NO. 2825

Intertwining grapes and leaves form the design in an overscale drawing of a brooch or pendant from Tiffany Studios (fig. 108). Here the tight interlacing ornament is highly compressed, presumably to be executed in enamel on gold with, perhaps, the inclusion of semiprecious stones.

One of the most extraordinary pieces of Tiffany's jewelry to survive is a hair ornament incorporating a remarkably realistic rendering of two dragonflies resting on two dandelion puffs, or seedballs (fig. 109). Dating to roughly the same year as the grape-cluster necklace or slightly later, the piece is thematically typical of his work and shows the plants not at the height of bloom but in a natural fading state, just before the seeds are blown away. Remarkably, one of the puffs is portrayed as already partially stripped of its seeds. This striking interpretation was achieved by the use of delicately worked platinum for the "silken" strands of the puffs, with green and yellow enamel on the small leaves just below them. The strands are surrounded by an almost imperceptible network of platinum that forms a sphere, to which minute dots of white enamel were applied. The dragonflies' backs comprise a row of graduated black opals in a rich fiery blue, and the heads and eyes are of pink opals and green demantoid garnets. An almost unbelievable creation in metal filigree, the gossamerlike wings were said to be a special alloy of iridium and platinum. All of these elements have been incorporated in an extremely complex design in a true feat of the jeweler's art. Although the piece was not included in the list of Tiffany's jewelry exhibited in St. Louis, other related items were—a single dragonfly and a hair ornament of dandelion seedballs. The dragonfly-and-

dandelion hair ornament illustrated here was acquired by Louisine W. Havemeyer.

Beginning in 1907, jewelry designed by Tiffany and fabricated under his direction was made at the workshops of Tiffany and Company, where production was supervised by Julia Munson (later Sherman), whom he had transferred from the enamels department at Tiffany Furnaces. When Munson retired in 1914, her post was filled by Meta K. Overbeck (working ca. 1914–33). The jewelry department was staffed predominantly by women designers and artisans, largely because Tiffany valued their dexterity and the skill they demonstrated in such delicate handwork. Pieces made

110. Louis Comfort Tiffany. Tiffany
and Company. *Necklace,* 1914–15.
Alexandrite, semiprecious stones,
and gold, l. 20 in. (50.8 cm).
Inscribed: (on back of pendant)
TIFFANY & CO. Gift of Sarah E.
Hanley, 1946 (46.168.2)

111. Louis Comfort Tiffany. Tiffany
and Company. *Necklace with
pendant,* ca. 1910. Moonstones,
Montana sapphires, and platinum,
l. 27 in. (68.6 cm). Inscribed: (on
backs of pendant and clasp)
TIFFANY & Cº. Gift of Susan Dwight
Bliss, 1953 (53.153.7)

under Munson and Overbeck, characterized by the two necklaces illustrated opposite, displayed a pronounced shift in style and workmanship. Explicit, handwrought flower forms were replaced by designs that relied on a high degree of finish, on the stones themselves—their color, shape, and texture—and on stylized filigree to make an elegant and bold statement.

A virtual compendium of semiprecious stones was strung on a gold necklace made at the Tiffany and Company workshops (fig. 110). They form a roughly symmetrical arrangement on both sides, but the stones—opals, garnets, tourmalines, carnelians, and amber—are in seemingly random order. Cut into faceted beads, some of them spherical, and into smooth oval or irregular shapes, the stones are separated by hand-wrought links and hammered gold beads. A large alexandrite, weighing over forty carats, is suspended from the chain. An unusual stone, especially in this size, its properties in changing light must have appealed to Tiffany. In transmitted or artificial light it appears as a deep orange-red amber color, and in reflected light, as a soft olive green hue. Three spessartite garnets are set below the alexandrite, which, in turn, is set in a scrolled framework covered in enamels of coordinating colors. The alexandrite was probably imported from Sri Lanka, but the other stones are native to North America.

During the Munson and Overbeck years, a number of Tiffany's jewelry designs displayed glowing moonstones, often set in platinum or in platinum and gold and enhanced by sparkling, small blue Montana sapphires. One of the most elaborate to survive, the Metropolitan's necklace features moonstones of irregular size and shape interspersed with a filigree design of twisted scrolls each enclosing four tiny Montana sapphires (fig. 111). A large medallion of moonstones and sapphires with elaborate filigree work is suspended from the chain. The detail of the filigree is extremely fine, and the scroll motif, which became a signature of Tiffany's jewelry, ties the entire composition together, as it not only appears on the chain but is also incised on the sides of the moonstones' mountings.

As was sometimes the custom of the day, the piece could be worn as one large elaborate necklace with a pendant, or it could be separated into discrete items, so that the owner (in this case Museum patron and jewelry connoisseur Susan Dwight Bliss) could wear it as a choker or a bracelet, and the pendant, independently, as a brooch. The points where the various sections joined together were skillfully and cleverly disguised. This combination of beauty and ingenuity is a testament to Tiffany's keen aesthetic vision and to his technical superiority as a jeweler.

METALWORK

Much of the Tiffany Studios' production was devoted to one-of-a-kind art objects—handblown vases, special order mosaics and windows, and exquisitely crafted jewelry—consistent with Tiffany's mission to bring beauty into the home. These items were sold at relatively high prices, affordable only for elite clients. However, the Studios also turned out more modest objects, such as metalwork desk sets, candelabra, and boxes—called "Fancy Goods" in the firm's 1906 price list—that were made in multiples. Such products were considered stock items and were on view in their showrooms and at Tiffany and Company. They were also marketed through illustrated catalogues.

Tiffany began manufacturing small metalwork objects about 1897, when he added a foundry to his glass furnace in Corona. His new products received international exposure two years later, when, in 1899, through the influence of Siegfried Bing, a selection was displayed at the Grafton Galleries in London. Later Tiffany greatly expanded the number and range of designs, and during the first two decades of this century his workshops turned out more than fifteen

112. Louis Comfort Tiffany. Tiffany Studios. *Picture Frame of "Etched Metal and Glass" design in pine-bough pattern,* ca. 1905–20. Favrile glass and gilt bronze, 10 x 8 in. (25.4 x 20.3 cm). Gift of Estate of John F. Scharffenberger, 1990 (1990.314.8)

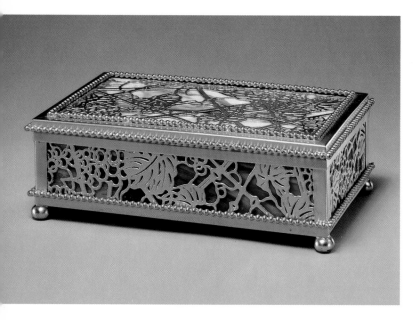

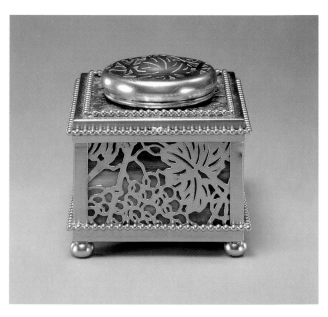

113. Louis Comfort Tiffany. Tiffany Studios. *Covered box of "Etched Metal and Glass" design in grapevine pattern,* ca. 1905–20. Favrile glass and gilt bronze, l. 6½ in. (16.5 cm). Gift of Estate of John F. Scharffenberger, 1990 (1990.314.1a,b)

114. Louis Comfort Tiffany. Tiffany Studios. *Covered inkwell of "Etched Metal and Glass" design in grapevine pattern,* ca. 1905–20. Favrile glass and gilt bronze, h. 3 in. (7.6 cm). Gift of Estate of John F. Scharffenberger, 1990 (1990.314.2a,b)

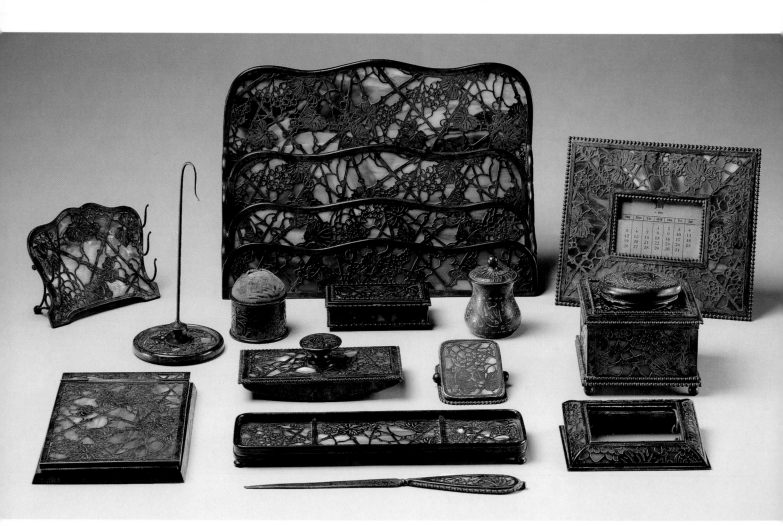

115. Opposite bottom: Louis Comfort Tiffany. Tiffany Studios. *Fourteen of twenty-six items from a desk set of "Etched Metal and Glass" design in grapevine pattern,* ca. 1910–20. Favrile glass and bronze, h. of paper rack 8⅝ in. (22 cm). Pen rack, bill holder, calendar, paper rack, pin cushion, stamp box, glue pot, blotter, pen tray, letter opener, inkwell, and notepad holder: Gift of Mrs. H. S. Mesick, 1962 (62.233.6,.7,.9,.14,.17a,b, 18a,b,.10a,b,.5,.3,.2,.4,.8). Paper holder (clip) and picture frame. Picture frame stamped: (on back) *TIFFANY STUDIOS / NEW YORK / 930.* Gift of Estate of John F. Scharffenberger, 1990 (1990.314.7,.6)

116. Louis Comfort Tiffany. Tiffany Studios. *Thermometer in "Bookmark" design,* ca. 1905–20. Gilt bronze, h. 8⅞ in. (22.5 cm). Stamped: (on back) *TIFFANY STUDIOS / NEW YORK / 1019.* Gift of Estate of John F. Scharffenberger, 1990 (1990.314.15)

117. Louis Comfort Tiffany. Tiffany Studios. *Pen tray in "Bookmark" design,* ca. 1905–20. Gilt bronze, l. 8½ in. (21.6 cm). Stamped: (on underside) *TIFFANY STUDIOS / NEW YORK / 1055.* Gift of Estate of John F. Scharffenberger, 1990 (1990.314.14)

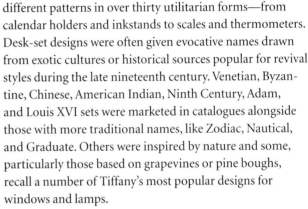

different patterns in over thirty utilitarian forms—from calendar holders and inkstands to scales and thermometers. Desk-set designs were often given evocative names drawn from exotic cultures or historical sources popular for revival styles during the late nineteenth century. Venetian, Byzantine, Chinese, American Indian, Ninth Century, Adam, and Louis XVI sets were marketed in catalogues alongside those with more traditional names, like Zodiac, Nautical, and Graduate. Others were inspired by nature and some, particularly those based on grapevines or pine boughs, recall a number of Tiffany's most popular designs for windows and lamps.

Among the earliest desk-set patterns were those incorporating Tiffany's signature Favrile glass. In grapevine and pine bough sets, glass, typically green, blue, or amber opalescent, was laid behind the etched and pierced metalwork design, permitting it to show through (figs. 112–15). Such patterns became, in effect, miniature versions of Tiffany's stained-glass windows. Other designs incorporated iridescent Favrile glass as small inlaid accents.

Most of Tiffany's metal wares were made of cast bronze or hammered or spun copper. Patterns were varied by the introduction of different finishes. Some desk sets were available in "antique" green (achieved through a chemical bath), in patinated brown, and plated with gold. The gold-finished items illustrated on these pages are so pristine that they appear as if just removed from their original boxes. Descended in the family of the bookkeeper (or accountant) for the Studios at the time the firm closed, they were carefully stored and never used.

Four designs were included in the Tiffany Studios price list for 1906—Etched Metal and Glass, Byzantine, Zodiac, and Bookmark. Illustrated here are a pen tray and a thermometer that could have come from a complete matched Bookmark set (figs. 116, 117). The design was available in plain gold (the pen tray), or in polychrome, with red coloring rubbed into the relief (the thermometer) for a

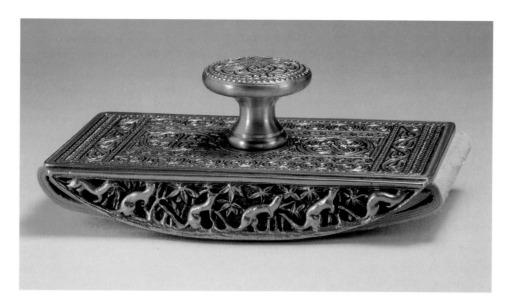

118. Louis Comfort Tiffany. Tiffany Studios. *Rocker blotter in "Venetian" design*, ca. 1905–20. Bronze, l. 5½ in. (14 cm). Gift of Estate of John F. Scharffenberger, 1990 (1990.314.12)

119. Louis Comfort Tiffany. Tiffany Studios. *Three-handled cup (tyg)*, ca. 1905. Silver and glass, h. 8 in. (20.3 cm). Stamped: (on underside) *TIFFANY STUDIOS / NEW YORK. / STERLING* / $\frac{925}{1000}$ / *4787*. Purchase, The Edgar J. Kaufmann Foundation Gift, 1969 (69.36)

slightly higher price. In an undated catalogue both forms were nineteen dollars in gold and twenty-two dollars for polychrome. Bookmark was very appropriate for a desk set, commonly used in a library: the various forms displayed different motifs, each representing the colophon of a notable printer in history. Tiffany used this subject in the wall decoration for the library in the home of his friend Robert W. de Forest in Washington Square, New York City, and also introduced it as an ornamental motif in the Chicago Public Library in 1897.

One of the more elaborate designs was Venetian, described in a 1920 trade catalogue as "decorated with fields of richly chased ornament relieved by a deeply carved band of ermines at the base of each piece." The band of ermines, used since at least the fifteenth century as a heraldic emblem, evoked noble associations. The top of the rocker blotter features highly compressed geometric ornament, which, according to the same catalogue, is in a "style used extensively in the Sixteenth Century by Venetian craftsmen in making tooled leather objects" (fig. 118). The set was finished in a dull gold.

Analogous to Tiffany's preference for semiprecious over precious stones was his favoring of base metals over precious metals for these wares. This may explain why he worked with such dedication in bronze and rarely in silver, a medium for which his father's firm was justly famous. Louis Tiffany began to use silver and gold only after his father's death in 1902, when he became both second vice president and art director of the firm. The three-handled cup, or tyg, is a rare example of silver marked by Tiffany Studios and presumably designed by Louis, but actually made by craftsmen at Tiffany and Company (fig. 119). The form of the cup evokes those seen in medieval metalwork, but has been transformed by

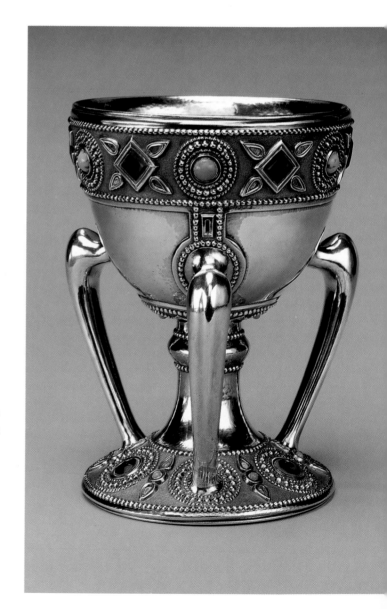

the addition of handles resembling animal bones. The applied jewel-like glass decoration is reminiscent of Native American or Mexican metalwork. There is a related stand in gilt bronze with colored-glass applications. In place of the bowl of the cup, it held a gold luster Favrile glass vase.

WOODWORK

Allied with Tiffany's metalwork designs are a small number of carved wood decorative objects, mainly forms appropriate to the study—small covered boxes, including those for

playing cards, humidors, and cigarette holders. The careful workmanship and innovative designs make them some of Tiffany's most unusual creations.

The small covered box illustrated at the left is carved out of a single piece of wood, the natural shape of which has been retained (fig. 120). A further indication of Tiffany's close attention to naturalistic detail for decorative effect is seen in the insertion of small pieces of iridescent glass in a pattern resembling a knot in the wood (fig. 121). The skilled craftsman also carefully articulated in low relief the wings of the scarab, which holds the box's spherical bronze hinge representing the sun disk. The insect's body is made up of a cast iridescent blue-glass jewel. Few examples of this meticulously crafted form are known and were only briefly, during the years around 1910, advertised in the Tiffany and Company *Blue Book*, indicating that such boxes were turned out in very limited numbers.

Another diminutive covered box is perhaps unique (fig. 122). The delicate carving of the water-lily leaves suggests finely tooled leather and is enlivened with tiny jewel-like dots of applied enamel. It was part of the large collection of Favrile glass and enamel wares that Tiffany's foundation loaned the Museum in 1925 and that later became a gift.

120. Louis Comfort Tiffany. Tiffany Studios. *Covered box*, ca. 1905–10. Wood and Favrile glass, h. 4½ in. (11.4 cm). Bronze monogram: (inside cover) *HJG;* circular incised mark: (on underside) *TIFFANY•STUDIOS•N•Y•* encircling *TS* monogram. Gift of Hugh J. Grant, 1974 (1974.214.10)

121. Detail, *Covered box* (see fig. 120)

122. Louis Comfort Tiffany. Tiffany Studios. *Covered box*, ca. 1905–13. Wood and glass, h. 2⅝ in. (6.7 cm). Stamped: (on underside) *TIFFANY STUDIOS / NEW YORK*. Gift of Louis Comfort Tiffany Foundation, 1951 (51.121.44a,b)

Laurelton Hall was Tiffany's architectural masterpiece. A unique and original creation, it was a total aesthetic environment. Although he hired a young architect, Robert L. Pryor, to prepare the working drawings, it is clear from the building's eclectic design and exotic decoration that Tiffany had a hand in every stage of the project—inside and out. Tiffany and his family had enjoyed a summer home in Oyster Bay, Long Island, beginning in the 1890s. However, it was not until 1902 that he began plans to construct his dream house. The impetus might have been the death in that year of his father, whose passing away may have relieved the son of any potential disapproval over the extravagant expenditures he would incur and whose generous bequest gave Tiffany the means to realize his ambitious plans. (The estate was said to have cost nearly $2 million to build.)

Conceived as a summer residence, Laurelton Hall, named for an old resort hotel on the site that Tiffany took down prior to construction, was situated on six hundred acres on a bluff at Cold Spring Harbor, on the North Shore of Long Island, overlooking the sound. A series of outbuildings, including stables, tennis courts, barns, greenhouses, and a gatehouse, and later his chapel from the World's Columbian Exposition, a studio, and an art gallery completed the estate. Terraced gardens with fountains and pools descended the hillside, providing magnificent views of the sound's ever-changing scenery. Mindful of the beauty of his natural surroundings, Tiffany planted flower beds and blossoming vines and trees, adding variety and color to the landscape with a painter's touch. On the mile-long meandering drive to the main house, visitors would pass a medley

123. Opposite: Detail, *Poppy capital, Loggia from Laurelton Hall* (see fig. 129)

124. *Laurelton Hall, Cold Spring Harbor, Long Island, New York.* Conservatory, daffodil entrance, and entrance loggia, ca. 1920s. Gelatin silver print, 8⅛ x 10 in. (20.5 x 25.4 cm). Gift of Robert Koch, 1978 (1978.646.6). Photograph by David Aronow

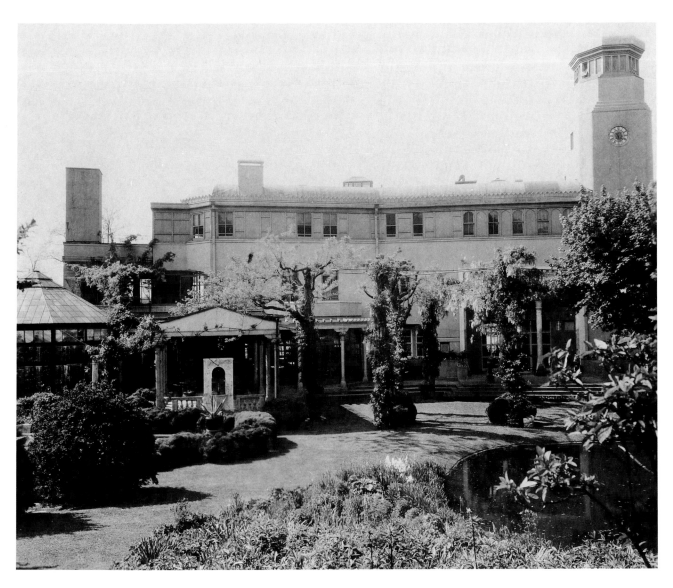

125. *Laurelton Hall, Cold Spring Harbor, Long Island, New York.* Hanging gardens looking toward smokestack and Cold Spring Harbor, ca. 1920s. Gelatin silver print, 8 ⅛ x 10 in. (20.5 x 25.4 cm). Gift of Robert Koch, 1978 (1978.646.25). Photograph by David Aronow

of such native vegetation as oak, hickory, dogwood, mountain laurel, and rhododendron. Some of the flora that appear most often in his art—magnolia trees and wistaria vines, for example—were prevalent on the grounds.

The stark concrete-and-stucco structure, with its blue-green patinated copper roof, adhered to no established architectural tradition but was Near Eastern in feeling. The eighty-four-room, eight-level building was carefully integrated into the contours of the bluff on which it was constructed. The house was further connected to the landscape by terraces extending from the main ground-floor rooms to the many gardens. At the heart of the complex was an unusual plant-filled, two-story octagonal court, integrating interior with exterior space and providing a central axis from which radiated the principal first-floor rooms and terraces. Islamic carpets and animal skins covered the marble mosaic floor. Stylized trees copied from an original Islamic textile were painted on the walls. The focal point of the court was a remarkable fountain surrounded by an octagonal pool lined with iridescent glass. From the center rose a three-foot high Favrile-glass vase of teardrop shape. Through its elongated, narrow neck, water rose until it "brimmed over and almost imperceptibly the drops trickled down the outside of the

bottle...and as the light fell on it the colors glimmered like mother-of-pearl." The water then flowed through a trough in the floor to the hanging garden outside.

Tiffany filled Laurelton's extensive rooms with his own works—windows, glassware, pottery, enamels, lamps—as well as ancient glass; Near Eastern ceramics and tiles; Islamic carpets; Egyptian antiquities; Chinese art; Japanese prints, *tsuba*, armor, and netsuke; and Native American baskets and textiles. A second-floor paintings gallery displayed many of his own oils and watercolors. Black-and-white photographs taken in the 1920s give some idea of the magical effects Tiffany achieved at this magnificent summer estate (figs. 124–28).

In 1918 Tiffany established a foundation to which he deeded Laurelton Hall, more than sixty-two acres, all of his personal collections, and a sizable endowment with the aim of establishing a program to nurture artistic talent in young men and women. Not intended as a place for technical instruction, Laurelton Hall was conceived instead as a haven for fostering creative freedom, the kind of atmosphere in which Tiffany himself had flourished. For fifteen summers, until he died, Tiffany enjoyed watching over and giving advice to the next generation of artists and seeing that his

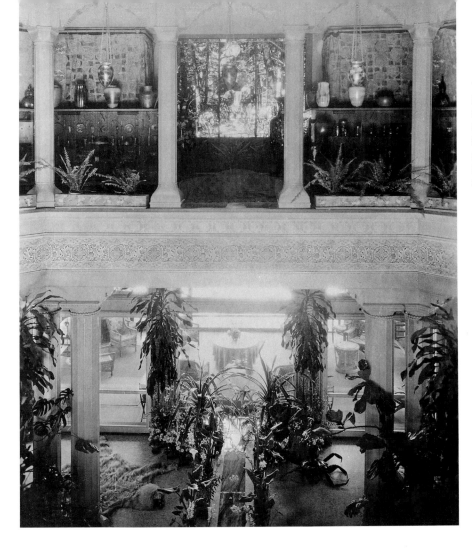

126. *Laurelton Hall, Cold Spring Harbor, Long Island, New York.* Central court seen from the second-floor balcony, ca. 1920s. Gelatin silver print, 10 x 8⅛ in. (25.4 x 20.5 cm). Gift of Robert Koch, 1981 (1981.1162.6). Photograph by David Aronow

127. *Laurelton Hall, Cold Spring Harbor, Long Island, New York.* Central court with octagonal fountain, ca. 1920s. Gelatin silver print, 8⅛ x 10 in. (20.5 x 25.4 cm). Gift of Robert Koch, 1978 (1978.646.18). Photograph by David Aronow

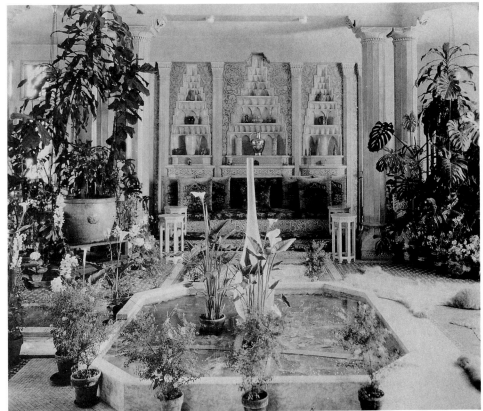

unconventional creation in Cold Spring Harbor gave them inspiration. About a decade after his death, however, the foundation deemed Laurelton Hall too expensive to maintain and determined that it, in fact, weakened the foundation's ability to support artistic talent. The trustees approved the sale of its contents at auction in 1946, and the land and house in 1949 for a fraction of their original cost. In 1957 the house was, tragically, destroyed by fire. Some of the original Tiffany decorations, however, were salvaged, including the four-column entrance loggia, with its vibrant floral capitals and glass-mosaic decorations, now installed in The Charles Engelhard Court in The American Wing. Other elements are preserved at the Charles Hosmer Morse Museum of American Art in Winter Park, Florida.

The entrance loggia in many ways epitomizes the artistic mission of Louis Comfort Tiffany in its combination of decorative art and architecture (fig. 129). The loggia derives directly from the eastern facade of a palace in the Red Fort at Agra, in India. The original was built of a distinctive uniform red sandstone, but Tiffany brightened his version, incorporating glass and pottery in its fanciful capitals. True to form, Tiffany found yet another novel use for his favorite medium. The stems supporting the glazed pottery blossoms are composed of many individual pieces of glass in shades of green.

The floral capitals themselves are a testament to Tiffany's lifelong quest for beauty in nature. Each is a botanically accurate depiction of a different flower. From left to right are the lotus, the dahlia, the poppy, and the saucer magnolia (figs. 130–33), all depicted in three stages of growth, from the bud at the bottom, just below the flower in full bloom, to the seed pod, crowning the very top of the capital, the whole composition given an exceedingly decorative aspect.

The loggia brings together in one work many of Tiffany's important influences. The overall concept is drawn from Indian architecture, the stems on the capitals are bound to resemble Roman fasces, and the glass-mosaic panels in the spandrels and the iridescent blue glass-tile frieze evoke Byzantine mosaics. Three paneled lanterns in iridescent gold and opalescent blue glass hanging from iron chains recall Celtic ornament. In his own way Tiffany combined all of these exotic sources and infused them with an original artistic sensibility to give a novel and fantastic quality to Laurelton Hall.

128. *Laurelton Hall, Cold Spring Harbor, Long Island, New York.* Front entrance loggia seen from the daffodil terrace, ca. 1920s. Gelatin silver print, 8 ⅛ x 10 in. (20.5 x 25.4 cm). Gift of Robert Koch, 1978 (1978.646.9). Photograph by David Aronow

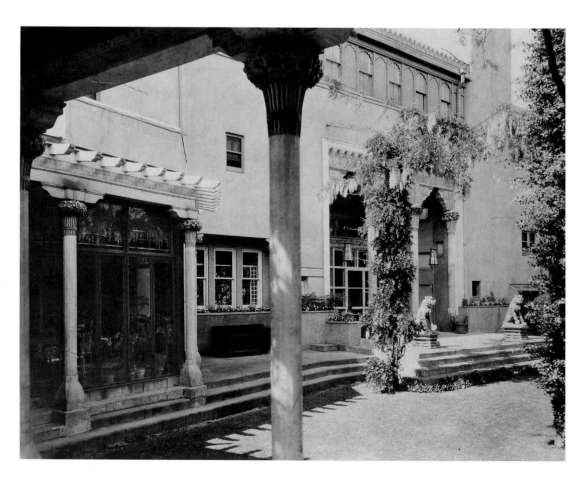

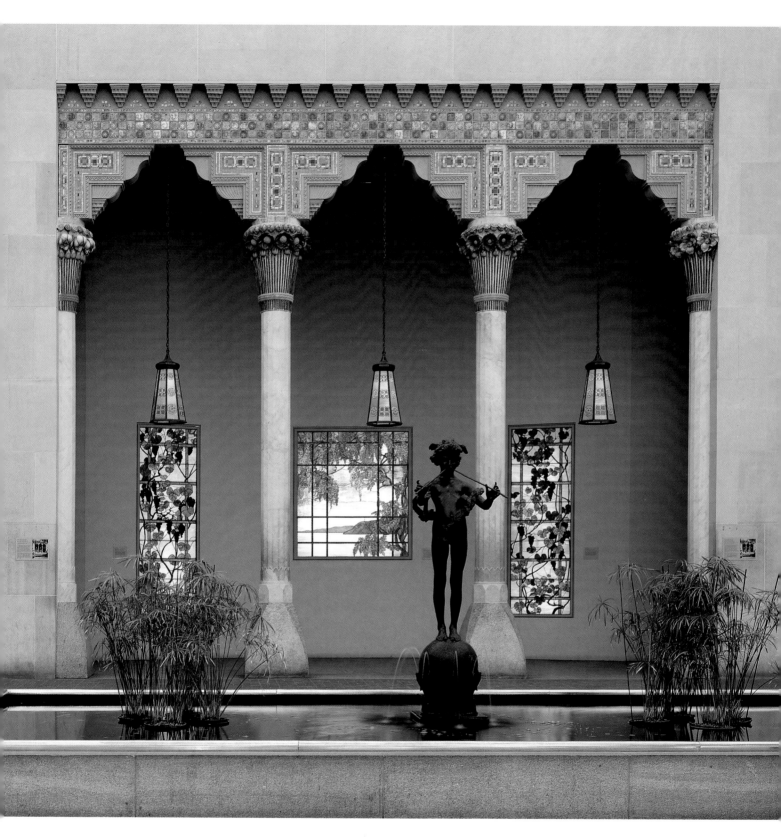

129. Louis Comfort Tiffany. *Entrance Loggia from Laurelton Hall, Cold Spring Harbor, New York,* ca. 1905. Limestone, ceramic, and Favrile glass, 21 x 23 ft. (640 x 701 cm). Gift of Jeannette Genius McKean and Hugh Ferguson McKean, in memory of Charles Hosmer Morse, 1978 (1978.10.1)

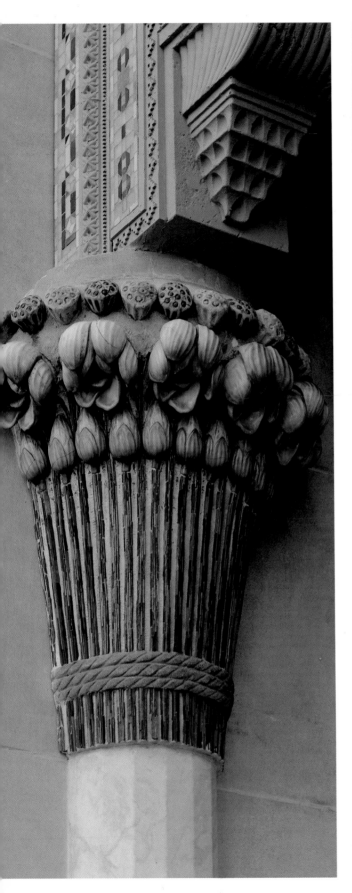

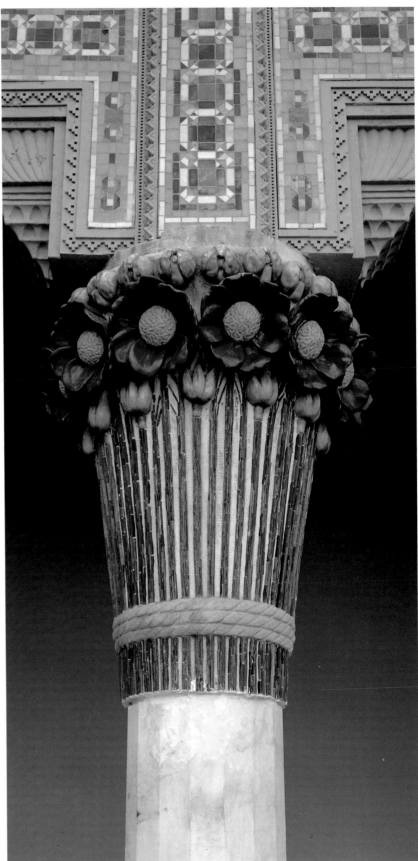

130. *Lotus capital, Loggia from Laurelton Hall* (see fig. 129)

131. *Dahlia capital*

132. *Poppy capital*

133. *Saucer magnolia capital*

NOTES

INTRODUCTION

P. 6 "indicates its mastership": Louis Comfort Tiffany, "Color and Its Kinship to Sound: Address before the Rembrandt Club of Brooklyn," *The Art World* 2 (May 1917), p. 142.

P. 7 "has yet produced": *The New York Times*, Sept. 15, 1872, p. 3.

INTERIORS

P. 10 "unity is delicacy": *Artistic Houses: Being a Series of Views of a Number of the Most Beautiful and Celebrated Homes in the United States* (New York: 1883), vol. 1, pt. 1, p. 1.

P. 11 "to the very fireside": Louis Comfort Tiffany, "The Quest of Beauty," *Harper's Bazaar*, Dec. 1917, p. 43. "Arabian Nights in New York": Alma Mahler Werfel, *And Love Is the Bridge* (New York: 1958), n.p.

P. 14 "beautifully distributed throughout": Louisine Havemeyer, *Sixteen to Sixty: Memoirs of a Collector* (New York: 1961), p. 16. "woodwork and chairs": Ibid., p. 18.

P. 18 "birds of brilliant plumage": *New Orleans Picayune*, Feb. 5, 1880. Quoted in Percy MacKaye, *Epoch: The Life of Steele MacKaye* (New York: 1927), p. 343. "embroidered . . . by Mr. Louis C. Tiffany": Quoted in MacKaye, p. 344.

P. 21 "prismatic tints": *Art Amateur*, 1885, p. 132.

P. 22 "Church Needlework": *Partial List of Windows* (New York: Tiffany Studios, 1910), p. 3.

P. 24 Description of Tiffany chapel taken from Tiffany Glass and Decorating Company, *A Synopsis of the Exhibition of the Tiffany Glass and Decorating Company in the American Section of the Manufactures and Liberal Arts Building at the World's Fair, Jackson Park, Chicago, Illinois* (New York: J. J. Little and Co., 1893), title page.

P. 26 "the most artistic produced": "Chicago-American vs. Foreign Stained Glass," *The American Architect and Building News* 42 (Nov. 1893), p. 75. Reprint of *The Board of General Managers of the Exhibit of the State of New York at the World's Columbian Exposition* (Albany: 1894), p. 87.

STAINED GLASS

P. 30 "with corrugated rollers": "American Progress in the Manufacture of Stained Glass," *Scribner's Monthly*, Jan. 1881, pp. 485–86.

P. 38 "entire cost $3,000": William [C.] Skinner, journal, 1904–14, entry for Sept. 10, 1908. Courtesy of Wistariahurst, Holyoke, Mass.

FAVRILE GLASS

P. 53 "heightened in some cases by a metallic lustre": "A Revival in the Art of Blown Glass," *Art Amateur* 3 (July 1894), p. 31.

P. 54 "collectors' cabinets": *Tiffany Favrile Glass* (New York: Tiffany Glass and Decorating Company, 1896), title page. "a new epoch in glass": Tiffany Glass and Decorating Company, "A Special Notice" [invitation to exhibition of Favrile glass], Oct. 1895. A copy is in the Archives, Smithsonian Institution, Washington, D. C.

P. 56 "to the Metropolitan Museum of Art": Letter from H. O. Havemeyer, dated Dec. 8, 1896. MMA Archives.

P. 57 "impression of real growth and life": S. Bing, "Louis C. Tiffany's Coloured Glass work," first published in German as "Die Kunstgläser von Louis C. Tiffany," *Kunst und Kunsthandwerk*, 1898, vol. 1, pp. 105–11, in S. Bing, *Artistic America, Tiffany Glass, and Art Nouveau* (Cambridge, Mass: 1970), p. 202. "gases or by direct application": U.S. Patent, Feb. 8, 1881. Reproduced in Robert Koch, *Louis C. Tiffany, Rebel in Glass*, updated third edition (New York: 1964), p. 48.

P. 58 "in her most seductive aspects": S. Bing, *Artistic America, Tiffany Glass, and Art Nouveau*, p. 211.

P. 63 For Kreischmann's obituary see "Artist Kreischmann Dead," *New York Morning Sun*, Aug. 13, 1898.

P. 66 "my flower garden": Emily Johnston de Forest, *The House, 7 Washington Square, and an Inventory of its Contents* [typescript], Apr. 1928. Department of Drawings and Prints (1971.645).

P. 67 "decoration suggesting Iris": two-page memorandum dated Nov. 18, 1925. MMA Archives.

P. 79 "with determination to try it": Adelaide Alsop Robineau, editorial in *Keramic Studio* 2 (Dec. 1900), p. 161.

P. 80 "delicate color reaction": Letter from H. O. Havemeyer, dated Dec. 8, 1896. MMA Archives.

JEWELRY, METALWORK, AND WOODWORK

Illustration on page 84 (top) copyright © Tiffany & Co. Archives, 1998. Not to be published or reproduced without prior permission. No permission for commercial use will be granted except by written license agreement.

LAURELTON HALL

P. 94 "glimmered like mother-of-pearl": Manuscript diary of Jean Gorely, entry for Sept. 1, 1923, in "Clues and Footnotes: Tiffany's Laurelton Hall, 1923," *The Magazine Antiques*, Jan. 1981, p. 233.